ZEN

城市禪園工作營
CITY ZEN GARDEN

by Haakon Rasmussen 河　康
Marco Casagrande 卡馬可
Chen-Cheng Chen　陳珍誠

A Abstract 摘要

2006年的淡江大學建築系國際工作營，經過與學生與老師的討論後，我們決定要到戶外做一些身體力行的設計與施工。國際工作營的主持人和我們的芬蘭籍客座教授卡馬可（Macro Casagrande）先生討論之後，決定邀請挪威奧斯陸來知名的建築團體3RW Architects的成員之一河康（Haakon Rasmussen）先生與卡馬可教授共同來淡水主持這個工作營。

國際工作營主題由卡馬可教授策劃，主題是「城市禪園」（City Zen Garden），原則上每一組學生得實地建造一座5.0公尺長，2.5公尺寬約一個車位大小的「禪園」。這次的工作營採自由報名參加的方式，參加的同學非常的踴躍，大約有200位，我們將這些學生分成了18組，除了建築系的專兼任老師之外，我們邀請了幾位研究所已經畢業的學長回來共襄盛舉，擔任各組的指導老師。

基地位於竹圍捷運站的後方，介於淡水河和台北捷運淡水線的軌道之間，經過系上黃瑞茂教授與當地農民的溝通後，免費提供我們使用這個場地。經過討論後，河康教授所帶領的九組（01-09組），在靠北邊的荒地上進行城市禪園的設計；卡馬可教授所帶領的九組（10-18組），在靠南邊的河邊潮間帶上工作，遙望著觀音山。經過四天的努力，各組的成果收集在這本小冊中。

關鍵字：國際工作營，城市禪園，竹圍，淡水河，觀音山。

The International Workshop in 2006 for the Department of Architecture, Tamkang University, after a discussion between students and teachers, we decided to go outdoors to do actual design and construction. After a discussion between the international workshop's host and our guest professor from Finland, Professor Macro Casagrande, we decided to invite Mr. Haakon Rasmussen, a member of the famous architecture group called "3RW Architects", to co-host the workshop. He came all the way from Oslo, Norway to Tamsui, Taiwan.

The workshop's subject was organized by Professor Macro Casagrande, and was called, "City Zen Garden." In principle, each team of students had to build a 5.0 meter long by 2.5 meter wide Zen Garden (about the size of a parking space). This was a free entry workshop. We had about 200 students sign up. We divided all of the students into eighteen groups. In addition to the full-time and part-time teachers from our department, we also invited several graduates to join the teams as group instructors.

The workshop was located behind the Zhu-Wei MRT Station, between the Tamsui river and the tracks of the MRT Tamsui line. Professor Huang Rui-Mao negotiated with the local farmers and convinced them to offer us the site for free. After discussions, Professor Haakon Rasmussen lead teams 1 through 9 to design City Zen Gardens in the wastelands of the northern section of the site. Professor Macro Casagrande lead the other nine teams, 10 through 18, to work on their projects in the southern section of the site, near the inter-tidal riverbank facing Guan-Yin Mountain. After four days of hard work, the final results from each team are collected in this booklet

Keywords: International Workshop, City Zen Garden, Zhu-Wei, Tamsui River, Guan-Yin Mountain.

P Preface 序

面對長河的數百名學生
河康

　　個人對於在淡水河邊工作營過最強烈的記憶來自於：學生在工作過程中嘗試各種不同對於河流可能的想像與態度；然而，一次次這樣的嘗試被寧靜的河水潮汐給吞噬了。我永遠不會忘記這些學生努力不懈地奮鬥著，不斷的加強他們設計的結構體以抗拒河流的力量。這是耕作人與自然的對抗，也是各種不同對待河流的態度與大自然力量的競爭。

　　整體而言，這是一個日益普遍的趨勢，身為建築師的我們常遵循既定的答案。我們真的沒有常常坐下來，找出我們所介入真實情況的侷限與周遭的可能性。我們通常選擇安全的解決方案，那些過去已經被嘗試過和被測試過的。我們也許是害怕新事情，也許是我們寧願相信有些人已經想過的事情，因此認為嘗試重新來過是毫無意義的。

　　今日全世界所面臨的全球經濟危機，對於個體、家庭與國家是嚴重的打擊。對於許多人來說，危機導致了困難的局面，並且得花上許多時間戰勝巨大的負面影響。同時，我們也看到一股巨大的浪潮於世界各地在政治意識高漲的一般民眾間形成。我們看到了在紐約的占領華爾街運動，2012年5月15日在西班牙的五月風暴，我們已經看到了大規模的阿拉伯之春茉莉花革命運動。經濟危機隱含著龐大的失業問題，社會與經濟的不確定性，讓我們有理由相信，未來許多國家的社會福利明顯地被削弱。可用資源的減少與不確定性增加的情況下，會導致一般民眾要通過正規與非正規的政治渠道處理與表達他們的需要與需求。同時，以目前的社會局勢看來，人們將活在較少的社會福利幫助之下，得更加獨立地經營他們的生活處境。換句話說，在未來成功的特質將是具有能力去經營與適應不同與不斷變化的情況，並且能夠理解在不同的環境下發揮最大極限的潛能。

　　當我與學生在河邊開始為期5天的工作，我希望他們與基地合而為一。希望他們界定一塊土地，以他們自己獨特的方式，透過他們共同的技能、感知、創造與熱情去培育它。我並不為他們設定的目標，或為他們的基地擔

Hundreds of students and one river
By Haakon Rasmussen

Perhaps the strongest memory I have from the workshop by the Tamsui River, is the image of all the various human expressions when the student works was being swallowed by the quiet force of the tide and somehow made uniform. I will never forget the students repeatedly struggle to improve and strengthen their constructions so that their effort would keep up with the force of the river. This struggle is the struggle between the cultivating man, and nature, but also the struggle between the multiple individual expressions, and the one big force.

Overall, there is a growing tendency that we rest upon conform and predefined solutions in our trade as architects. Not so often do we really sit down and figure out the actual limitations and possibilities of the territories we intervene in. We usually choose the safe solutions, the ones that have been tried and tested before. We are perhaps scared. Perhaps we have the belief that someone already has figured this out, and that it would be meaningless to try to reinvent the wheel.

A major part of the global world is today facing a global economic crisis with deep impacts for the individual, for families and nations. The crises are undoubtedly resulting in difficult situations for many people with great negative consequences that can prevail for a long time. At the same time we also see a great wave of increased political awareness and mobilization among average people around the world. We have seen the Occupy movement in New York, the 15-may movement in Spain and we have seen the extensive Arab spring. The economic crisis has so far implied great unemployment, social and economic uncertainty and there are reasons to believe that we in the future will see a significant weakened welfare state in many countries. A situation with less available resources and increased uncertainty will lead average people to address and express their political needs and demands through formal and informal political channels. The situation will at the same time require that people to a greater extent acts independently and manage their situation and life with less help from the welfare state. In other words, success criterias in the future will probably be the ability to engage and adapt to different and changing situations, and be able to understand and maximize the potential in such changing landscapes.

When I started the 5-day work with the students on the bank by the river, I wanted them to become one with their sites. I wanted them to define a piece of land, for their own particular reason, and then cultivate it, by using all of their collective skills, senses, creativity, and passion. I was not so worried about which goals they set for

心。區域內幾乎荒廢也沒有太多的設施，我知道他們主要的目標將會是打造一處給他們自己在這幾天內能夠使用的場所。一個工作、吃飯、討論和實驗的場所。透過這些勞動，他們具體實現了這次活動的核心；他們為了他們的設計提案耕作了這片土地。他們將原本某種屬於無名的場所，轉化成為獨特的。

這意味著與海德格的存在的概念有著有趣的理論連接；身為一個人處於一個特定的基地中將如何面對與處理現有獨特的經驗。此外，在傅柯佈署的概念中亦可以看到，在他早期的作品中專注於如何構成內部結構、條件和機制力量在不同的情況下，與人如何不可避免地隱藏並維持著這種關聯性。然而，他在後期關於反抗的作品中，強調反思人類挑戰既定的思路和框架，透過新的嘗試產生自我轉換的能力。

當我回想起不同組的學生在淡水河邊工作時，我不認為他們當中有人準備以常規與保守的步驟去處理他們的基地。他們開始調整自己與基地之間的關係，並不斷發展自身的行動以探索基地的可能性與侷限性。工作營其中有一條規定是，他們不能由基地外帶進任何新材料，他們不得不在這基地上探索和發現，這個基地不僅僅是一個舞台，它本身也是一種工具。

幾天下來，學生們開始改變了，更像一般人，也更像建築師。他們學會穿什麼樣的鞋能夠在泥濘中達到最佳的工作狀態，何種鐵鍬與挖掘裝備能夠提供最佳的性能等。他們必須要調整自己。他們與自己的基地同步，漸漸成為這個基地上的專家。他們挖掘土地上不同的層積與內容，他們將垃圾分類並試圖尋找出何種碎片具有能夠被利用的特性。他們回收了自己基地上的廢棄物，並將其重新組織。

也許這是最真實的一課。事實上，這些未來建築師們的腳陷入爛泥當中，試圖挑戰一個不會有明確目標或最終完美結果的工作，使他們只能儘量接近真實，以及在這種情況下，他們想扮演的角色。真正的基地在工作營這幾天裡才開始真正運作，就如同在河畔邊基地工作學生的內心世界一樣。

themselves, or for their sites. The area was quite deserted and without many facilities, so I knew that one of their prime goals would eventually be to make a place for themselves for these days. A place for working, eating, discussing and experimenting. By doing these activities, they manifested the very core of this exercise; they cultivated the land for their purposes. They made something that was anonymous, into something that was highly personal.

This implies some interesting theoretical connections to Heidegger's concept of Dasein; the unique experience of existing as a human being in a particular site and how to confront and deal with this. Further it can be seen in the context of Foucault's concept of the Dispositif. In his early works he focus on how structures, conditions and mechanisms constitute power inside different situations and how persons inevitably are implicitly complicit in maintaining this. However, in his later work on resistance he emphasizes reflexivity and the human ability to challenge conformity, established thinking and frameworks by producing new practices and the transformation of the self.

When I think of all the different student groups at the Tamsui River, I don't believe any of them rested on any conventions in their approach or in their procedures. They all went in tune with their sites and continuously adjusted their actions to the possibilities and limitations of the site. As one of the rules of the workshop was that they could not import any new materials into their sites, they also had to explore and discover their sites in this respect; the site not only as an arena, but as a tool itself.

Over the days the students changed, as persons, as architects. They learned what kind of shoes that worked best in the wet mud, which shovels and which digging-equipment that gave the best performance and so on. They adjusted themselves. They had to. They went in sync with their sites, and gradually they became experts on the site. They discovered the different layers in the ground and their contents, they sorted rubbish and figured out which debree that had properties they could utilize. They recycled their sites, and recomposed them.

Perhaps this is the real lesson learned. The fact that the architects sink their feet in mud and are challenged in a task that does not have a defined goal or end-result, makes them define how they will approach, and who they want to be in this situation. he real sites that were worked on during these days were just as much inside the individual students as on the ground by the river.

長河勿擾
卡馬可

我很榮幸與淡江大學建築系合作，於2006年組織一年一度的國際工作營。從卑爾根的挪威建築學院來的建築師 Haakon Rasmussen-Wiesener（3RW建築師）與我聯手合作 "都市針灸" 這個競圖，一個為期一週的工作營 "城市禪園" 在新北市竹圍的淡水河邊。這個工作營自由地在建築與環境藝術間穿梭透過學生在環境中的身體勞動完成。

都市針灸競圖作品一般來說有很輕質的圖像海報或更屬於個人對都市創傷的表達，時常看到臺灣建築學校的電腦技能超越批判性思考與解決問題的能力。在大多數的情況下，學生們自己編造問題，而不是有足夠的信心來處理每天圍繞在現實或對正常生活感到疑問。設計是一種投機的方式遠離現實。

在實際的工作營中，學生們和老師們被送往竹圍在有限的時間與實際的環境中以1:1的尺度工作，可以避免這種設計取代現實或使用治療/裝飾藝術和建築的危險。

基本上全系的學生都參與了除了忙著文憑的五年級與研二的學生。除了大學身為工作人員的教授與10名訪問學者被邀請參與領導學生組。 還有180名學生參加了工作營的一部分。

這次研討會的基礎建立在透過觀看日本禪園的傳統藝術的現代城市理論。禪園是一種環境冥想的視覺平台，與人的本性連結在部份的自然與進一步地宇宙整體間。

一方面人們可以看到禪園中有如反映了周圍環境的山就像縮小比例的石頭一樣，或是如海洋運動一般的礫石紋理。冥想可以建立禪園與其周圍的自然元素之間的連接和動態，冥想還可以顯示出張力，平衡與指引自身與禪園的元素間並幫助觀看者消除禪園周圍的現實讓心靈旅遊在受到高度控制的環境中。

禪園的矛盾在於它是受到高度控制的自然，就像做為一

CITYZEN GARDEN - CAN'T PUSH A RIVER
by Macro Casagrande

I was honored to co-operate with Tamkang University's Department of Architecture in order to organize their annual International Workshop in 2006. Architect Haakon Rasmussen-Wiesener (3RW Architects) from the Bergen School of Architecture Norway teamed up with me to run a competition "Urban Acupuncture" to be followed with a one week workshop "CityZen Garden" in Zhuwei by the Danshui river of Taipei. The workshop was moving freely in-between architecture and environmental art with the students being present in the environment through physical labor.

The Urban Acupuncture competition entries were in generally speaking quite light weight graphical posters or expressions of more personal urban based traumas, something that is often seen in the Taiwanese architecture schools where the computer skills are overtaking critical thinking and real problem solving. In most cases the students had been inventing problems rather than being confident enough to deal with everyday surrounding realities or questions of normal life. Design can be a cheap escape from reality.

This danger of design replacing reality or using art and architecture for therapy/decoration was avoided in the actual workshop where the students and the teachers were taken to Zhuwei to work in 1:1 scale with limited time in real environmental conditions.

Basically the entire department was involved except the fifth class and the second class of master's students, who were engaged with their diploma works. Besides the staff professors of the university some 10 visiting scholars were invited to participate in leading the student groups. 180 students took part in the workshop.

The workshop was based on the theory of viewing the modern cities through the traditional Japanese art of Zen gardens. The Zen garden is a visual platform for environmental meditation linking the human nature as part of nature and further to more cosmic entities.

On one hand one can see the Zen garden as a reflection of the surrounding environment scaling down the mountains into its stones or the movement of the ocean into the racking pattern of the gravel. Meditation can build connections and dynamics between the elements of the Zen garden and its surrounding nature. Meditation can also reveal tensions, balances and directions between the Zen garden elements themselves and help the viewer to erase the realities around the garden letting the mind travel in this highly controlled environment.

The paradox of the Zen garden is in its highly controlled nature as a platform of accident. It may be, that the form of the garden has remained the same for hundreds of years having every element

個無法預期的平台。這可能是將數百年中花園的形式一直保持相同，當中的每個元素都銜接到它們應有的位置，砂礫與沙所形成的平台、僅僅是樹成長的紋理、圍繞在石頭旁青苔的顏色......一切都沒有改變，但有件事必須承認，微風的輕拂可能改變一部份的沙粒或使樹葉由樹上掉落，使相同的園藝工作重新開始。這種極致的人為控制讚頌了最微小的環境變化當中的優越性。

我們試圖控制數百萬人的城市，但我們很容易忘記本質，我們能夠創造環境，當人性不再是大自然的一部分。花園是一個永恆的窗口。

都市混合體

如果禪園是嘗試著建立一個與自然的和諧，那麼人們的行為與都市的關係不存在「時間」；而時間是重要的精隨。這樣的辯解導致現代都市型塑了人工時間並創造了壓力。在時間與金錢造成的壓力，死亡成為了挫敗，一種徹底的失敗。

都市必須成為一種混合體。

在自然中的死亡是一個新生命的開始。當一顆樹正在成長時，它是幼嫩柔軟的，但是當它乾枯堅硬時，它死去了。硬直與暴力是死亡的左右手。柔軟與柔弱是生物初生的表現。當人們剛出生時，他是軟弱、柔韌的；當他死去時是堅硬，不具感知的。「因為堅硬永不勝利」。（《潛行者》，塔可夫斯基）

當我們請學生想像禪園，並且請他們想像如何在都市中創造禪園，城市禪園幫助我們在後都市時代中冥想。遲緩城市，針灸都市主義，新的都市遊牧—一種像似庭園的混合體。

工作營對主導者來說會是一份困難的工作。他必需要夠敏銳的察覺目標，瞭解創造當下來反應未來。對於都市禪園

articulated into their exact position – the racking of the sand or gravel, the pattern of the growing or merely being of the tree, the color of the moss around the stone...nothing has changed but still one has to admit that the slightest breeze of the wind might turn one piece of the sand or fall down a leaf from the tree and the same gardening work has to be started again. This ultimate human control celebrates the superiority of the smallest of the environmental changes.

We try to control cities with millions of people. And we easily forget the nature. We are capable of creating surroundings where human nature is no longer part of nature. Garden is a window of eternity.

Urban Compost

If a Zen garden is trying to build a harmony between the natural elements, the human nature and the universe the city does not seem to have the time. And the time is in essence. To justify its being the modern city has created the artificial time and invented stress. After stressing for time and money death has become a defeat - a bankruptcy.

City must be a compost.

In nature death is the beginning of new life. When a tree is growing, it is tender and pliant, but when it is dry and hard, it dies. Hardness and strength are death's companions. Pliancy and weakness are expressions of the freshness and being. When a man is just born, he is weak and flexible; when he dies he is hard and insensitive. Because what has hardened will never win. (Stalker, Tarkovsky)

We asked the students to think about the Zen garden and we asked them to think about the city to create a new Zen garden for the city, the CityZen Garden to help us to reach a level of post-urban meditation. The city of slowness, the urbanism of acupuncture, the new urban nomad – in a compost, as a garden.

The workshop was a big task of a creator. One had to be sensitive enough to look for the horizon and gifted enough to present the reflections of the future. The thinking and creations of the CityZen Gardens rose up questions of the urban development of the postindustrial city, questions of taking the needed steps towards ecologically sustainable directions and questions about the role of an urban planner or architect in this development. The different interpretations of the CityZen Gardens were quite freely mixing the different disciplines or urban planning, architecture, landscape architecture and environmental art and landing down to an open form.

的想像與創造激盪出後工業都市發展的問題，問題提出了都市設計者對於永續與生態方向的步驟。對於都市禪園的不同解釋形成不同的分歧，它是都市策劃，建築，景觀建築，或是環境藝術的開放形式。

開放形式

竹圍是一個實現禪園的極佳地點。它已經有著被捷運、住宅區、商業區建築物所環繞的菜圃與都市農場。淡水河成為自然中最大的聲音，每日引導節奏與主軸到出海口與海洋地平線。位於河流西邊的山脈的呈現，讓都市儼然是一個暫時的現象。

學生們分成兩邊。一半在河邊，另一半在接近捷運的草地。兩邊的學生各分成9組。河邊9組需要在2.5公尺寬的地區連結來自於上游獨自的灌溉系統。這個大型9組的鄰里庭園之關鍵字就是「開放形式」，當建築元素與環境變更是需要去被設計來反應現在的狀況。

其他的學生在捷運樹叢旁的9組可自行尋找基地，而他們可以在大約是2.5 x 5公尺大的地方建造自己的庭園。

不久之後，當對話深植於潛意識當中，奇異的庭園便開始發生。在河岸邊的大型庭園必須要配合自然尺度，與自然物理力量，像是潮汐抗衡。較小的庭園儼然成為一個安全的踏入另一個意識的門戶或是介面。許多的小庭園敘事性很強，孩童記憶的物理形式或是秘密基地好像成為無法控制的力量，形成短暫的工業廢棄拼貼或是專注於自然的永恆輪迴。當學生放個石頭並且坐在庭園中，聽到關於「死亡」與「生命」的對話非常正常。

許多秘密與個人冥想空間，因為自然開始給予學生休憩與自由可能性的條件下成型。所有的材料都是在基地上找到的。每一個都是在很短的時間中因應基地條件而重組並拼湊。

Open Form

Zhuwei proved to be an excellent place to realize the gardens. There already exists community gardens and urban farms surrounded by the MRT –line and residential and commercial buildings. Danshui River plays the big sound of nature with its daily tidal rhythm and axis towards the river mouth and further to the ocean horizon. Also the mountains to the West of the river are present, city feels quite temporary.

The students were divided in two sections: one half to work by the river and one half in the grasslands and bushes closer to the MRT –line. Both of these sections were divided into 9 groups. The 9 riverside groups were tasked to work attached to each other cultivating individually a 2,5 meters wide area starting from the upper bank of the river all the way down to the water. The key word for this big community garden of nine groups was the theory of "Open Form" where architectural elements and environmental manipulation is designed to invite other forms or reactions into the present situation.

The other 9 groups in the bushes near the MRT were let to go free and find themselves individual sites where they would like to build their gardens roughly the size of one car parking space 2,5 x 5 meters.

It did not take long until the conversations were deep in the subconscious and weird gardens started to happen. Whereas the big garden by the river had to cope with the big scale of nature and with actual physical natural powers – such as the tide; the smaller gardens were safe to become gateways or interfaces through where to step into another consciousness. Many of the small gardens were highly narrative, physical forms of childhood memories or hiding places and some were taken form as driven by some uncontrollable powers into temporary collages of industrial waste framing or focusing the eternal circulation of nature. Quite normal was to hear a dialogue about "Death" and "Life" while students were placing a rock to sit on in a garden.

A lot of secrets and personal meditation spaces started to get realized as if the nature had given the students a possibility to relax and feel free to open themselves. All the material used was found on the site. Everything that was build was temporary reorganizing of found objects and reactions to site specific conditions

The big garden was hard. One had to cope and negotiate with the neighbors and the area of the site was constantly changing according to the tide. The tide also destroyed day after day all the decorative constructions that did not understand its force. Nevertheless the students to whom the Danshui river had possibly been a questionable

大型庭園比較困難。它需要配合周遭鄰里以及因為潮汐而持續改變的基地。潮汐也摧毀了所有不知其力量的裝飾性造物。不論如何，學生認為淡水河可以成為臺北的後花園，剛開始不太敢接觸的學生，很快地光著腳踩在泥濘中仔細討論面對山脈正確的角度。不管庭園的美感如何，淡水河毫無疑問地成為學生表演之中的真實自然元素。在河流條件下表演沒有其他的辦法：自然不需要改變它的裝飾。

當然結果這個大庭園很快樂地看起來比較像是道教思想所造成的影響，而非禪式影響。但是這樣的發生是讓人感動的。時間改變了，可能時間或是河的韻律、植入人們能量而進入了庭園。庭園的時間，非都市時間，但比較像是人的時間，或是自然的時間，或是只是：時間本身。

畢教授的小組花很多時間挖了半公尺深的洞，並且在裡面洗淨每一個元素，再把它填回去。當然，這樣的動作不過是個對於臺北，或是臺灣其他都市面對自然議題的儀式性表達方式。但還是誠懇的，尊敬的，也是重要的。當淡水河回到它自然狀況下，臺北乾淨了，而河流成為創傷。如果建築師也是個園丁，他是個建造者。如果他不是個園丁，他會是個破壞者—這裡存在著一個危機。

我們也問到一位坐在位於大型庭園腳踏車橋上的五歲小孩：「學生們在做甚麼？」「他們正在做捕捉螃蟹的陷阱，然後把他們烤來吃。」

你的老媽不住在這裡

基於之前臺灣國際工作營的經驗來看，我認為臺灣的建築學校國際工作營是需要的。學生必須要被送到一個不熟悉的環境，並且比較他們與其他地方學生的工作技巧。這樣會幫助他們評斷自己的技術，並且讓自己冒著風險，成為實驗者的角色。大學通常是一個過於安全的玩樂場所。

back yard of Taipei, something you really don't want to see were soon standing bare foot in the mud discussing the right angle to sit and contemplate the mountain. No matter of the aesthetics of the garden the Danshui River had become the dominating unquestionable real element of nature where the students felt performing at. Performing on the conditions of the river after realizing that there is no other way - nature don't need decoration and one can't push a river. .

Of course the big garden ended up happily looking more Dao than a Zen garden but still again something very touching seemed to have happened. Time had changed. Maybe the time or the rhythm of the river had gotten into the garden or maybe the amount of human energy had done it but anyhow the time in this garden was not city time but more like human time, or nature time, or just time.

Professor Bee's group used their time to dig up half a meter of the landfill soil in their area and cleaned away every man originated object of it and then put the top soil back. Of course this is a merely symbolic gesture towards the ecological rehabilitation that Taipei as well as the other Taiwanese cities are facing, but still honest, respectable and important. When Danshui River is back to its natural condition the conscious of Taipei is clean – now the river is a trauma. If architect is also a gardener, he is a constructor. If he is not a gardener, he can be a destructor – there is a danger.

We asked some 5-years old kids on the bicycle bridge just above the big garden by the river what they think the people by the river bank are doing. "They are making traps for the crabs and then they will barbeque them."

Your Mother Does Not Live Here

Based on the international workshop and previous cases in Taiwan and abroad I feel the international workshops in the Taiwanese architecture schools are needed. The students should be send to abroad to work in unfamiliar conditions and comparing their working skills to the ones of the students from abroad. This will help them to value the working skill they have and also push them to the role of an experimental creator and taking risks. University is often a too safe place to play.

International scholars and student groups should be invited to Taiwan to contribute and challenge the Taiwanese students and schools. There is a great potential in the Taiwanese students what comes to computer skills and working discipline. What is lacking is down to earth touch to reality and bigger masses of people in society. For example in the student projects the city is often viewed as an

國際學者與學生小組應該被臺灣邀請來指導與挑戰臺灣學生與學校。臺灣學生有很好的電腦技術與工作紀律。而缺乏的是接近真實與跟更大的人們群體接觸。舉例來說，學生認為都市是一個主題樂園，在虛擬或是假想的環境是很簡單逃離現實生活的問題，更不用說是社會責任感。在 軍隊裡最棒的經驗就是，當你在學習如何整理你的房間時，班長大吼著：「你的老媽不住在這裡！」

臺灣的經濟和民主在許多方面是在亞太地區最先進的國家之一。它也必須接受更多的永續建築或是生態復原的挑戰。這裡有許多必須要解決的高度工業化後遺留的問題。當都市基礎在沒有自信與認同感的環境下，學生持續抄襲西方建築並且悄悄地崇拜日本的解決方案，更不用說到中華文化的累贅包袱。許多這樣的事是想像的，可以公開的經過工作而解決－如果問題是在校園中或是工作中。這樣的幫助是可以以藉由國際學者來參訪，並且讓學生面對外國人看到的臺灣現實問題。這樣也幫助了學生以不同的經驗與面相來瞭解他們國家的價值。

沒有人是自己居住地的預言家，外部的觀察是需要的；我們很容易的被每日生活蒙蔽了真實。臺灣應該要成為一個更有責任的角色，在解決自我都市問題後，來引導周圍過度工業化與都市化的國家。在準備當這樣的角色，建築系學生應該需要熟悉與國際合作，並且面對真實的家鄉環境問題。經過這樣的方式，臺灣的建築可變得更有價值，甚至重要；至少健康。

amusement park and virtual or fictive realities seem to be an easy way to escape dealing with normal life question, not to mention taking social responsibility. In army the best thing is that you learn to clean up your room when the Sergeant shouts: Your mother does not live here!

Taiwan is economically and in democracy in many ways one of the most advanced nations in the Asia Pacific and should be the one taking the most challenging steps what comes to sustainable architecture or urban ecological restoration. There is a lot to deal with inside the country from the heritage of the hyper industrialization period. The city based lack of confidence and identity has left the students in the cross fire of copying western architecture and being silently admiring the Japanese solutions not even to mention the cultural burden of China. In many ways all of this is fictive and can be opened up and dealt with through the work – if the tasks are the right in university and in working life. For this it is helpful to have international scholars visiting the country and making the students to face the Taiwanese realities as an outsider sees them. It is also helpful to take the students to work abroad to value their home country from another experience and perspective.

Nobody is a prophet in his own land, the saying goes. External observations are needed; one gets easily blindfolded for the real realities around the everyday life. Taiwan should also take a more responsible role in helping the surrounding countries in dealing with the heavy industrialization and urbanization after dealing with its own cities. To prepare for this role the architecture students should get familiar with working more internationally and facing real time the environmental problems back home. Through this the Taiwanese architecture can become valuable, even important – at least healthy.

卡馬可作者為2004-2008淡江大學建築系客座教授。並且持續與淡江建築系透過工作營，研究與教學合作保持相當之學術關係。

I INTRODUCTION 簡介

淡江大學建築系國際設計工作營

城市「禪」園
CityZen Garden

TAMKANG INTERNATIONAL WORKSHOP

CityZen Garden

計劃中的競圖與工作營主要的想法是反省現代化的城市，從一個傳統日本「禪園」（ Zen Garden ）的觀點。「禪園」是一座調和環境視覺的平台，連結人造的自然使它成為自然的一部份，並成為宇宙的一個元素。

「禪園」反映著周圍的環境，將雄偉的山巒縮小成為石頭，將大海的波動縮影為細石的環狀波紋。「禪園」的元素與週圍環境中的自然的連接與互動將引發無限的沉思。「禪園」中的沉思將產生張力、平衡、與方向，幫助觀賞者脫離真實，使得心靈到達更高的層次。

「禪園」最不可思議之處就是對於大自然的控制有如一連串的意外。五百年來「禪園」中各個元素的位置一點兒都沒有改變，除了園中樹木的生長與石頭上長出來的青苔。人為的對於環境中最小元素的控制達到了極致。

我們想要控制百萬人的城市，但是我們卻輕易的 忘記了自然。我們所創造出來的環境是人為的自然，但是已經無法再是原生自然的一部份。我們的環境是人為的自然，但是已經無法再是原生自然的一部份

The proposed competition and workshop is based on the theory of viewing the modern cities through the traditional Japanese art of Zen gardens. The Zen garden is a visual platform of environmental meditation linking the human nature as part of nature and furthermore to more cosmic entities.

On one hand one can see the Zen garden as a reflection of the surrounding environment scaling down the mountains into its stones or the movement of the ocean into the racking pattern of the gravel. Meditation can build connections and dynamics between the elements of the Zen garden and its surrounding nature. Meditation can also reveal tensions, balances and directions between the Zen garden elements themselves and help the viewer to erase the realities around the garden letting the mind travel in this highly controlled environment.

The paradox of the Zen garden is in its highly controlled nature as a platform of accident. It may be, that the form of the garden has remained the same for 500 years having the every element articulated into their exact position the racking of the sand or gravel, the pattern of the growing or merely being of the tree, the color of the moss around the stone...nothing has changed but still one has to admit that the slightest breeze of the wind might turn one piece of the sand or fall down a leaf from the tree and the same gardening work has to be started again. This ultimate human control celebrates the superiority of the smallest of the environmental changes.

We try to control cities with millions of people. And we easily forget the nature. We are capable of creating surroundings where human nature is no longer part of nature.

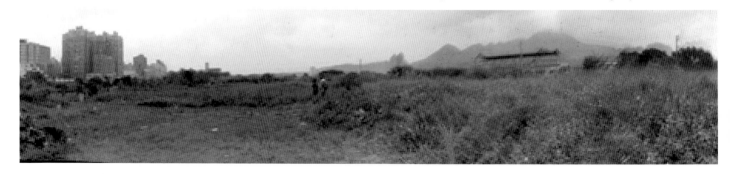

花園是永恆之窗　城市是有機的混合物

花園是永恆之窗。（Garden is a window of eternity.）

　　「禪園」嘗試在自然的元素中創造出一種和諧，人造的自然與城市的氛圍並未考慮到時間的因素，而時間是一個重要的本質。為了矯正這一點，現代城市發明了人造的時間與壓力。但是當時間的壓力與金錢的遊戲面臨挫敗，於是乎城市就破產了。

城市是有機的混合物。（City must be a compost.）

　　在大自然中，死亡同時是一個新生的開始。樹木開始生長時是脆弱柔軟的，但是樹木變得乾與硬的時候，就是它死亡的時候。堅硬與力量是死亡的伴侶。脆弱與柔軟代表著新生。當嬰兒出生時，脆弱但是靈活的，但是人行將就木時，是頑固並且感覺遲鈍的。因為頑固是無法戰勝任何事情的。

　　我們邀請學生思考「禪園」的同時，並思考我們的城市。我們希望學生創造出新的花園根據「禪園」的想法，以幫助我們達到另一層次「後城市」的冥想。慢城市（city of slowness）、都市針灸（urbanism of acupuncture）、與新都市游牧族（new urban nomad）將呈現在這有機的花園中。

　　這是一件創造者的傑作。我們應該很敏感的將這恩賜在未來反映給其他所有的人們。「禪園」的創造與思考，可以讓我們反思「後工業化城市」（post industrial city）該如何發展？如何邁向永續生態的方向？以及建築師與都市計劃師所應該扮演的角色。我們期待看到學生關於這方面的討論，我們期待對於「新禪園」的不同詮釋，這些詮釋可以來自於不同的背景 - 建築、都市計劃、景觀建築、環境規劃、以及各種可能的生態再生計劃。

Garden is a window of eternity.

　　If a Zen garden is trying to build a harmony between the natural elements, the human nature and the universe the city does not seem to have the time. And the time is in essence. To justify its being the modern city has created the artificial time and invented stress. After stressing for time and money death has become a defeat - a bankruptcy.

City must be a compost.

　　In nature death is the beginning of a new life. When a tree is growing, it is tender and pliant, but when it is dry and hard, it dies. Hardness and strength are death's companions. Pliancy and weakness are expressions of the freshness and being. When a man is just born, he is weak and flexible, when he dies he is hard and insensitive. Because what has hardened will never win.

　　I ask the invited students to think about the Zen garden and I ask them to think about the city. I ask them to create a new Zen garden for the city, the CityZen Garden to help us to reach a level of post-urban meditation. The city of slowness, the urbanism of acupuncture, the new urban nomad ? in a compost, as a garden.

　　This is a task of a creator. One has to be sensitive enough to look for the horizon and gifted enough to present the reflections of the future for the rest of the people. The thinking and creations of the CityZen Gardens can raise up questions of the urban development of the post industrial city, questions of taking the needed steps towards ecologically sustainable directions and questions about the role of an urban planner or architect in this development. I want to see this discussion to be handed over to the students and I want to see the different interpretations of the CityZen Gardens coming from the different disciplines or urban planning, architecture, landscape anrchitecture and environmental planning and landing down to a free form of ecological rehabilitation.

ZEN
城市禪園工作營
CITY ZEN GARDEN

CITY ZEN GARDEN

T Tutors 國際工作營老師

「城市禪園」(City Zen Garden)
工作營指導老師

A.河康 (Haakon Rasmussen)
01. 王俊雄
02. 林志帝 + 吳靜方
03. 楊恩達
04. 蘇睿弼
05. 李佩璋 + 林欣蘋 + 張舜翔
06. 楊尊智
07. 謝明達
08. 徐昌志 + 郭思敏 + 蔡孟芬
09. 李盈芳

B.卡馬可 (Macro Casagrande)
10. 黃瑞茂
11. 曹羅羿
12. 邱鄭哲
13. 畢光建
14. 加藤義夫
15. 李馬文 + 宋偉祥
16. 張恭領
17. 江之豪
18. 鄧海 + 何其昌

Hakaan Rasmussen
建築師 / 3R-W Architects · 挪威。
Architect / 3R-W Architects, Norway

柏根建築學院（Bergen School of Architecture）教授。
Teacher / Bergen School of Architecture

Marco Casagrande
赫爾辛基大學
University of Helsinki

W WORKSHOP DESCRIPTION 題目說明

每一小組將設計與構築一座「後工業的再生」（post industrial rehabilitation）花園。每一座花園常5公尺，寬2.5公尺，相當於一個停車位的大小。

Each group will design and build an rchitectonic garden for post industrial rehabilitation. Each garden will measure in plan 2, 5 x 5 meters equaling to one car parking space.

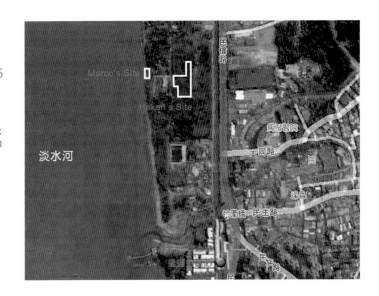

S Site 基地位置

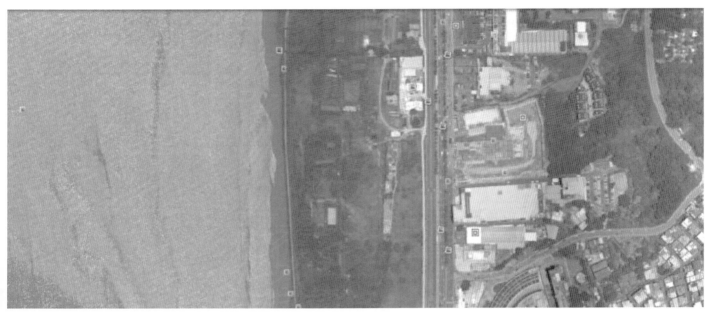

Site 1 : Hakaan Rasmussen
Site 2 : Marco Casagrande

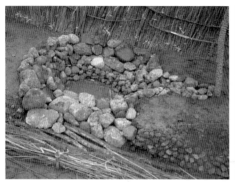
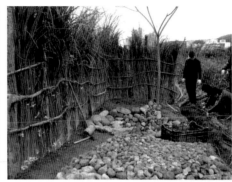
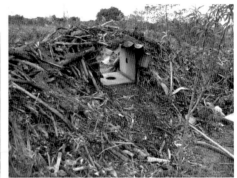
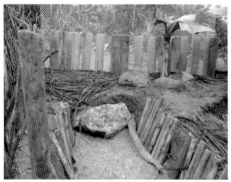
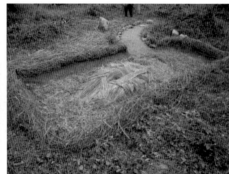
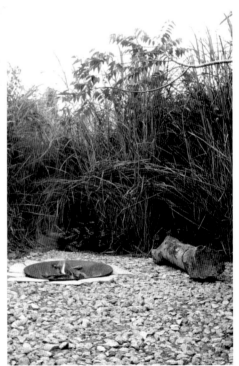
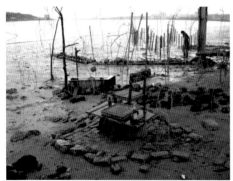
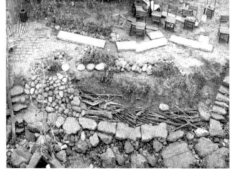

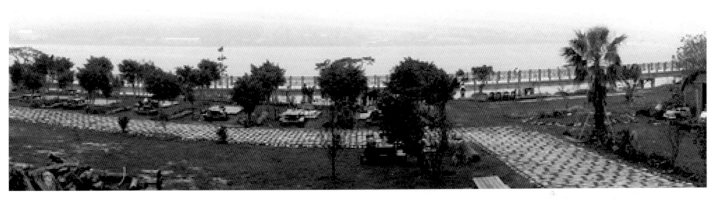

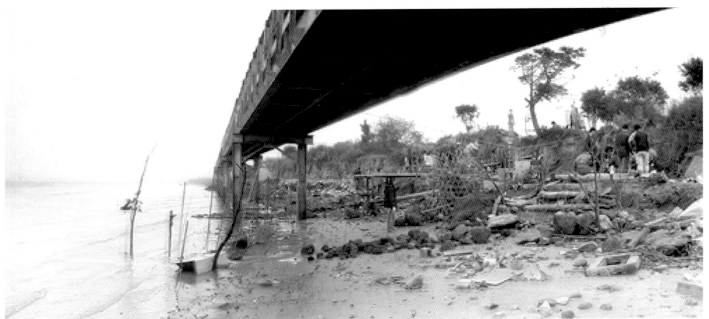

ZENGarden

01 / 地平線上的禪園
/ The Zen Garden on the Horizon

01組　王俊雄　林頎軒　蕭易兒　方琳　陳馨怡　吳宜倫　張淑婷　顏紹竹　鄭如庭　陳蕊希　徐啟泰　林哲宇

地平線上的禪園

　　基地位於捷運線旁的荒廢基地，在接近基地的動線與視線上，以現存的自然材質做為區隔與自然的中介。設計導引著基地的出入口，並凸顯基地內唯一的樹種。基地往下挖40公分深的溝渠，進入的人可以比肩而坐，觀者的眼睛以接近地平線的視野，觀看觀音山群並且體會種植與自然的感覺。

The Zen Garden on the horizon

　　The site is located on an abandoned place by the MRT line. Close to the moving line and the line of sight, the existing natural materials separate the area. The design guides the entrance to the site, and highlights the only tree species in the site. Digging out a 40 centimeter deep ditch from the ground, there is a seat where entering people can sit side by side and the viewers' vision is close to the horizon. Viewers can look at Guanyin Mountain and experience plants and nature

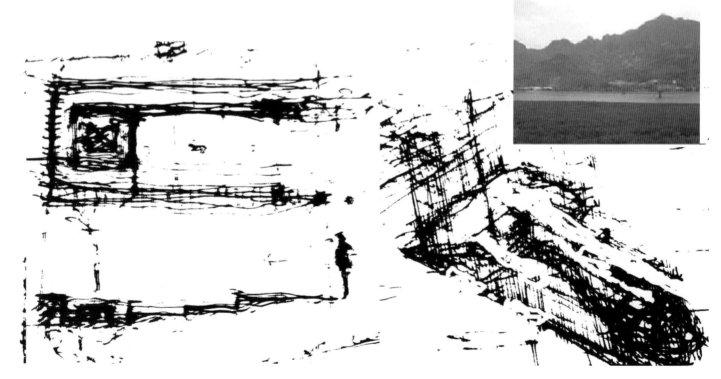

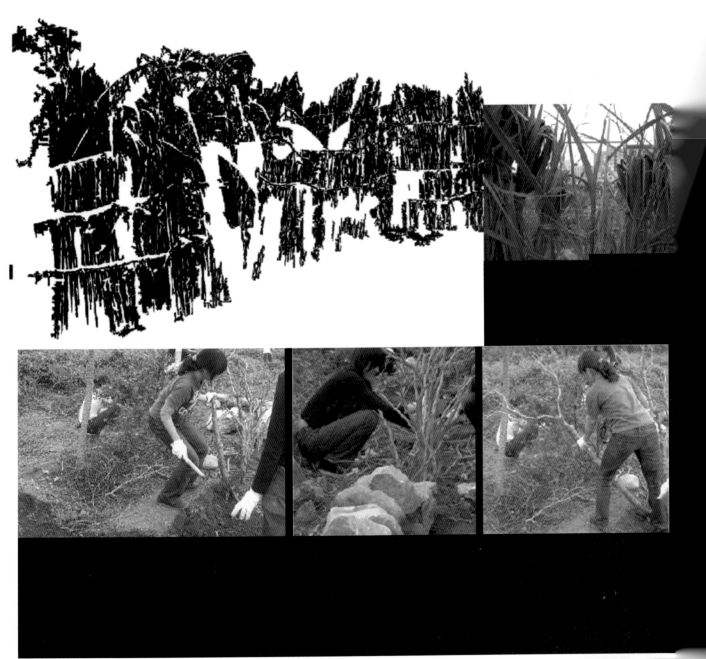

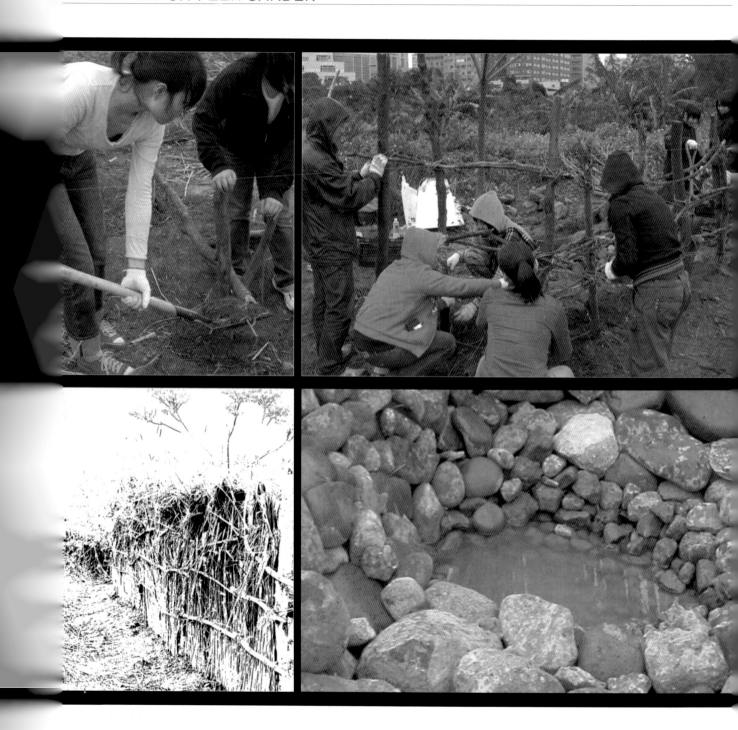

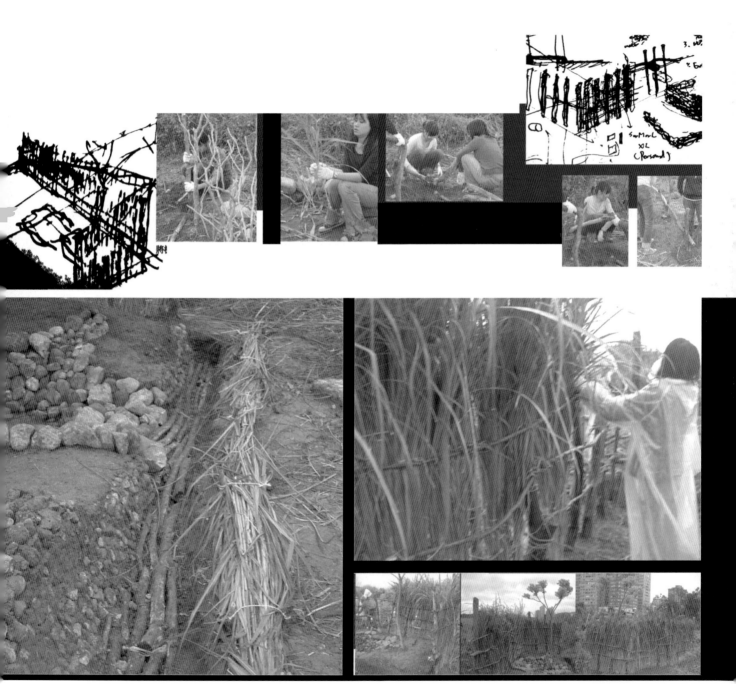

ZENGarden

02 / 腳踏實地的禪園
/ The Zen Garden down to Earth

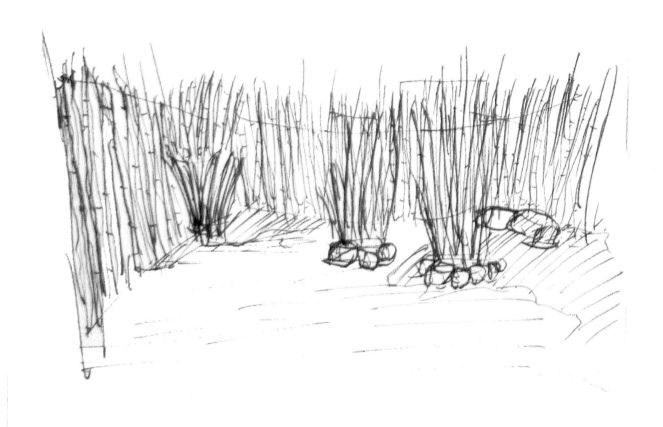

02組　林志帝 / 吳靜方　鄒永廉　廖子翔　林宏聰　莊明蕙　李訓銘　蔡宜礽　吳奕瑋　蔡昀昕　吳柏緯　黃玉彬　徐衛邦

C Concept概念說明

腳踏實地的禪園

　　人們是這麼不小心任意的將廢土與垃圾清倒於荒野中，這應該就是所謂的環境汙染吧。將這些人類製造的垃圾慢慢的由草叢與泥土中清出，花了大家許多的時間，也讓我們體會到一時的傾倒，得花上這麼多的時間清理。然而，整理完場地後有一股莫名的成就與平靜感。在其中整理出的荒地上，舖上一層河邊挖來的細沙，大夥兒脫下鞋子，赤足踩在細沙與土地上，也算是辛苦工作之餘對於自己的獎勵吧！

The Zen Garden Down to Earth

　　People are careless and arbitrarily dumped waste and dirt into the field. That is probably what we refer to as environmental pollution. We slowly cleaned the trash from the grass and the soil. It took a lot of time, and gave us the feeling that it only takes a moment to dump trash but takes so much time to clean it up. We felt accomplished and calm after we finished the place. We laid over the fine sand we had dug from the riverside and put on the place we had finishing cleaning. We all took off our shoes, and rewarded ourselves with a barefoot step on the fine sand on the ground.

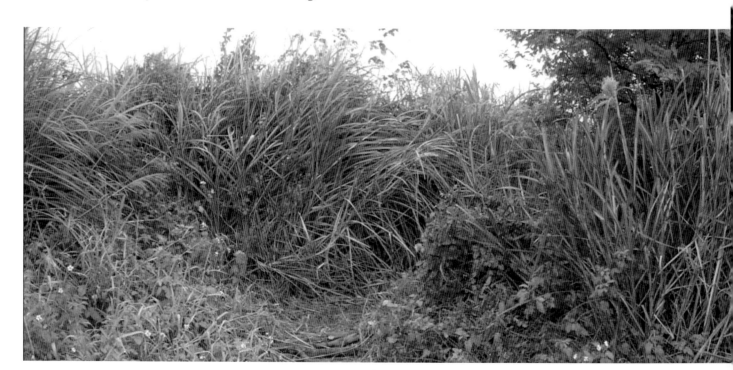

13

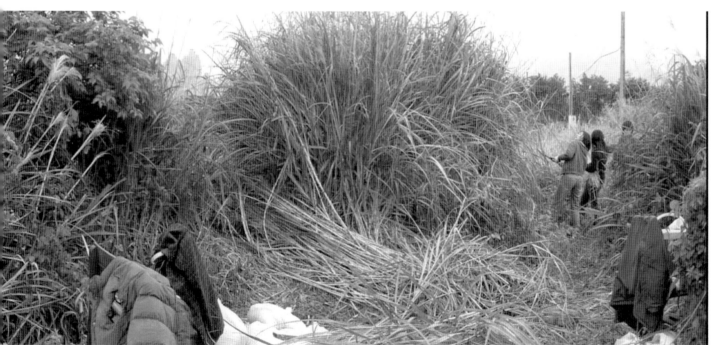

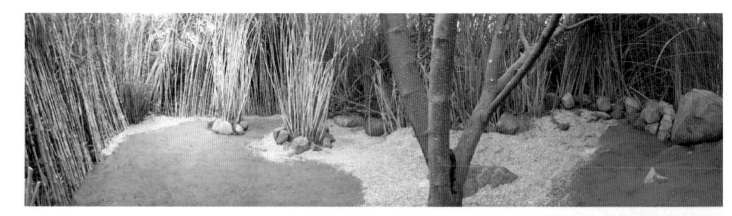

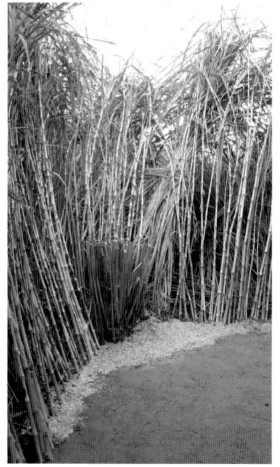

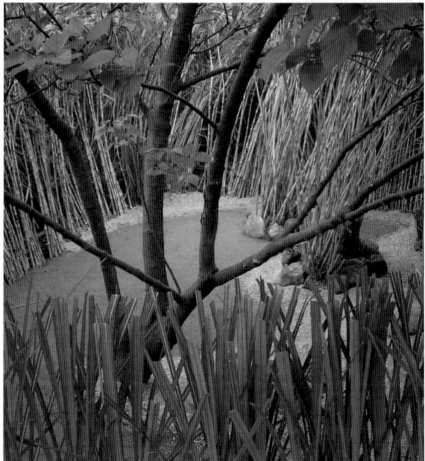

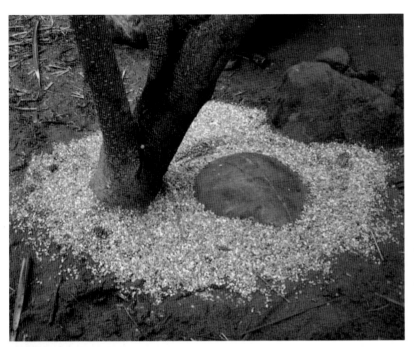

03 / 重返自然的禪園
/ The Zen Garden Returns to Nature

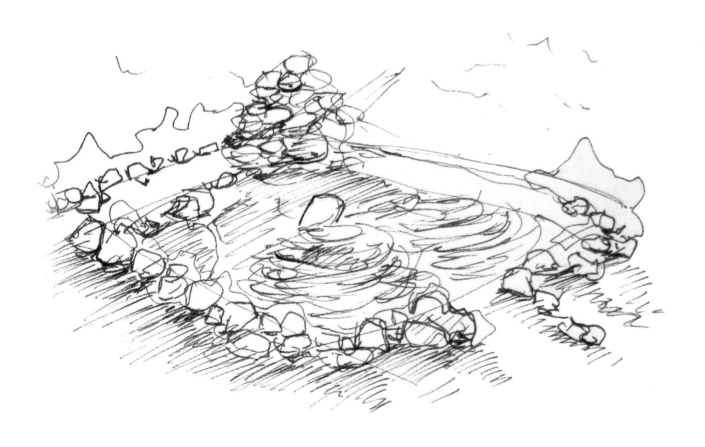

C Concept概念說明

重返自然的禪園

　　土地本來是生機盎然的，但是隨著人造物的入侵，甚至人造廢棄物的傾倒，我們的土地生病了。我們的做法很簡單，在所選擇的基地上將其中的元素加以整理分類：自然的、人工的、與廢棄的；這些元素包括：綠芽、雜草、枯葉、枯草、枯樹枝、小石頭、大石塊、與破磁磚，成為佈置禪園的元素。我們在基地上往下挖掘約30公分，將設計元素依照生、老、病、死的循環關係安排，嘗試讓瀕臨死亡的土地重現生機。

The Zen Garden Returns to Nature

　　The land was lively, but with the invasion of artificial products, or even the dumping of human waste, our motherland was sick. What we did was rather simple. We organized and classified the elements of the site we had chosen into natural, artificial, and abandoned. In these groups included things like green shoots, weeds, leaves, hay, dry twigs, small stones, large stones and broken tiles. We used them as the decoration elements of the Zen Garden. We dug about 30 centimeters deep into the land, and arranged the design elements accordingly by birth, age, sickness and death cycle relationships, and tried to give the dying land a chance to get back to life.

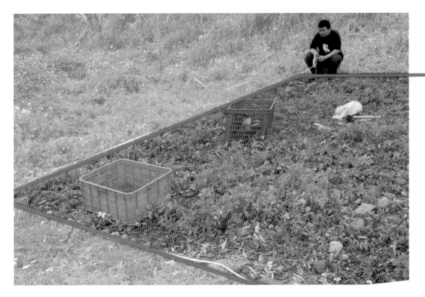

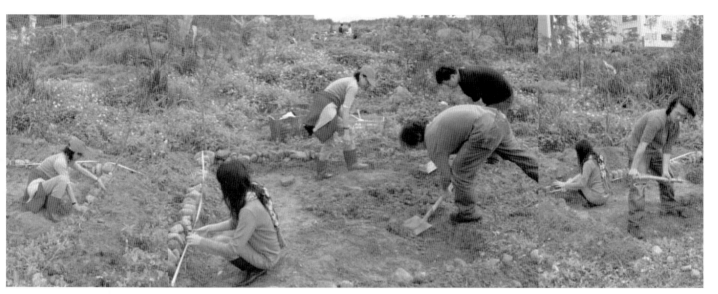

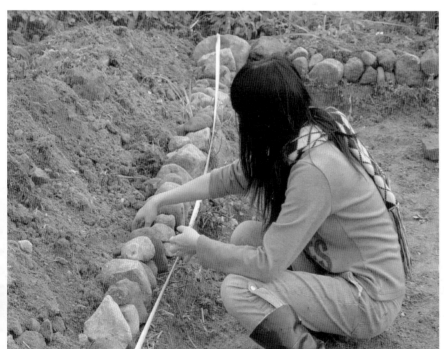

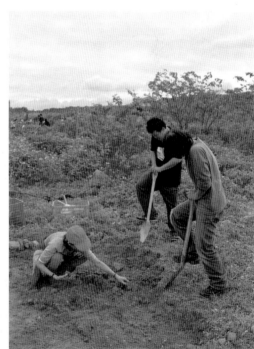

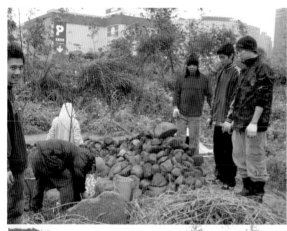

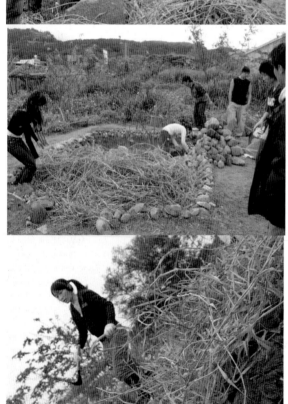

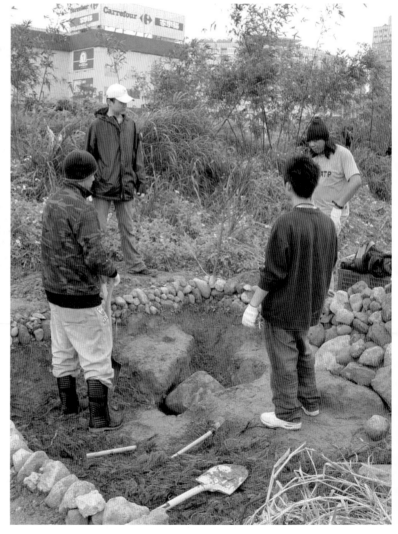

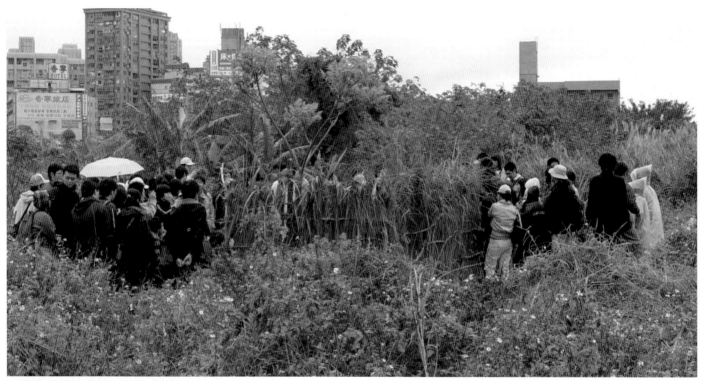

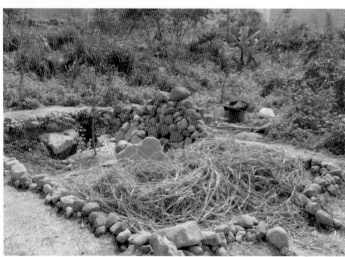

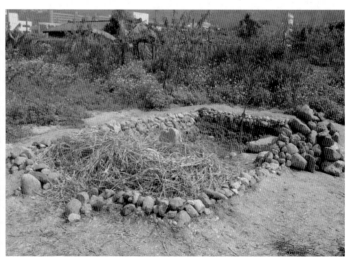

04 / 大地之聲的禪園
/ The Zen Garden of the Voice of the Earth

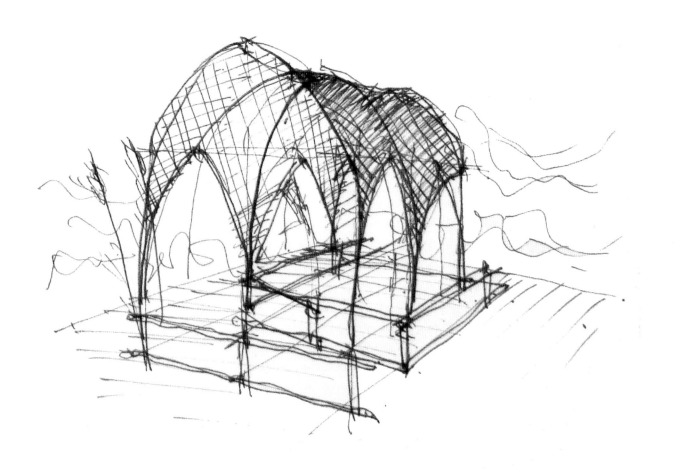

04組　蘇睿弼　　　陳敏傑　林蘊亭　莊馥名　杜偉立　謝嘉羲　蔡宜臻　蔡靜緹　蔡逸鈞　林耀正　范舒雅

C Concept概念說明

大地之聲的禪園

　　基地中充滿著各種自然的聲音，遠遠還傳來捷運車廂通過的震動聲。撿來了兩個甕，將這兩個甕埋入土中，在泥土中埋藏兩個空的房間，當雨水從空中落下，我們將雨水加以收集，滴入甕中，希望滴落的雨水聲就在大地中迴盪、迴盪著，呼應著遠遠傳來的捷運震動聲。

The Zen Garden of the Voice of the Earth

　　The site is full of the voices of nature, and there is also the sound of the vibration of the MRT trains from afar. We picked two earthen jars, and buried them into the soil, so there were two empty rooms in the soil. When rain drops from the air, the water gathers into the earthen jars, drop by drop, and hopefully the sound of the raindrops echoes inside the land and echoes the sound of the vibrations of the MRT trains from afar.

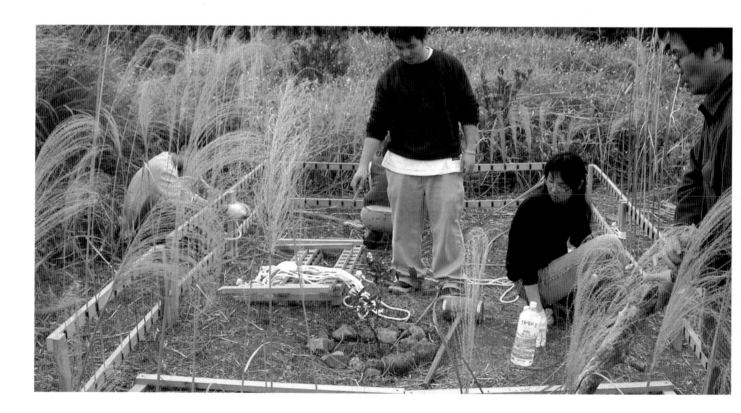

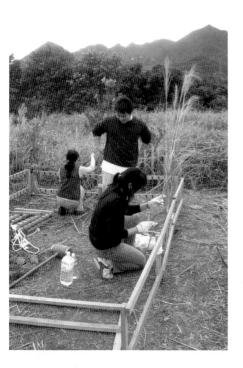
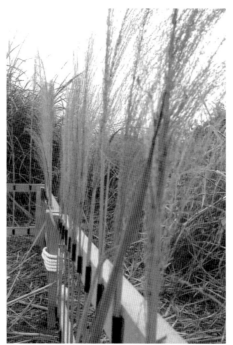
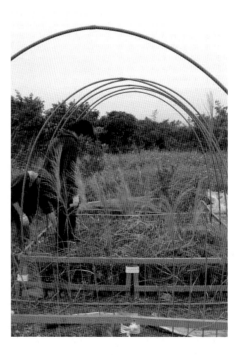
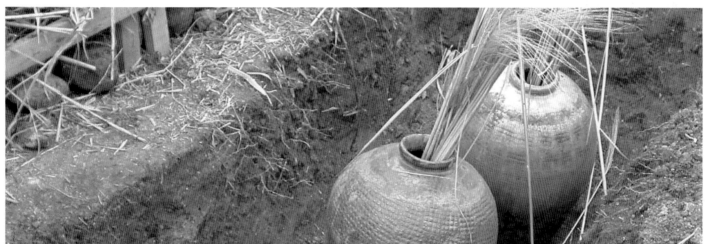

ZENGarden

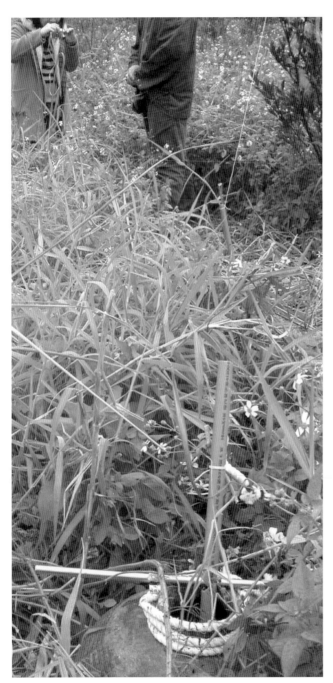

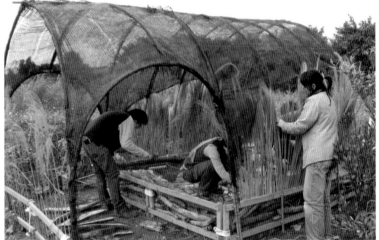

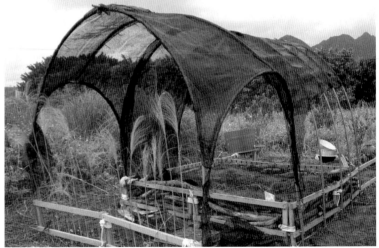

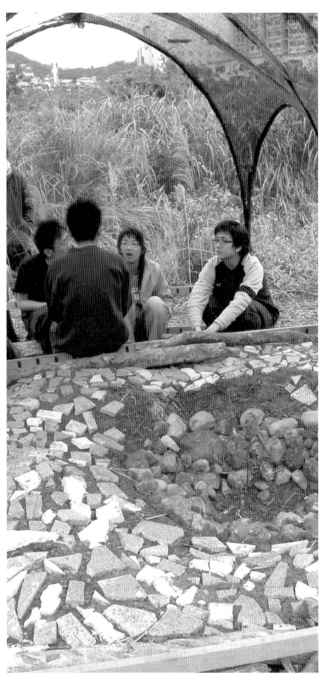

05 / 有機禪園
/ The Organic Zen Garden

C Concept概念說明

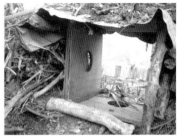

有機禪園

　　基地上因為之前農夫準備耕作，之後又放棄耕作，所以有著被翻攪的泥土與不少枯樹枝與樹幹被夾雜著丟棄在這乏人關心的土地上。於是我們將枯樹枝與樹幹重新從土中拉出，然後依造枝幹的粗細重新在基地旁堆砌成矮牆，然後將從地上挖起的新鮮土壤，覆蓋在矮牆上，圍塑成一個小空間，並設計出小窗戶可以由內而外或由外而內地張望，展現出對於自然的兩個視角。這矮牆也可視為一種新的堆肥方式，或是荒野中的一個隔間。

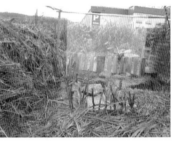

The Organic Zen Garden

　　There was a farmer planning to farm on the site, but he gave up eventually, so a lot of the soil had been welling up, and dead branches and tree trunks had been dumped carelessly onto the property. Therefore, we pulled the dead branches and the tree trunks out of the soil, and we piled them into a low wall from the sizes and the shapes of the branches. We dug the fresh soil from the ground and used it to cover up the low wall. We molded it around making a little space, and we also designed a little window that you can look out of or look into, presenting two perspectives of nature. This low wall could be seen as a new way to compost, or as a compartment in the middle of the field.

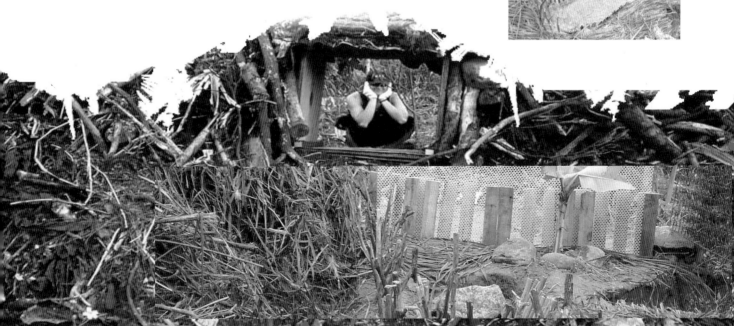

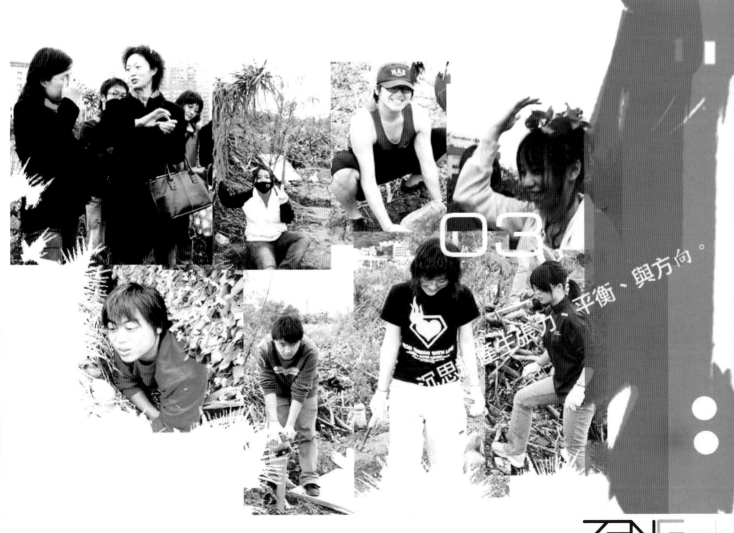

03

釋放張力、平衡、與方向。

ZENGarden

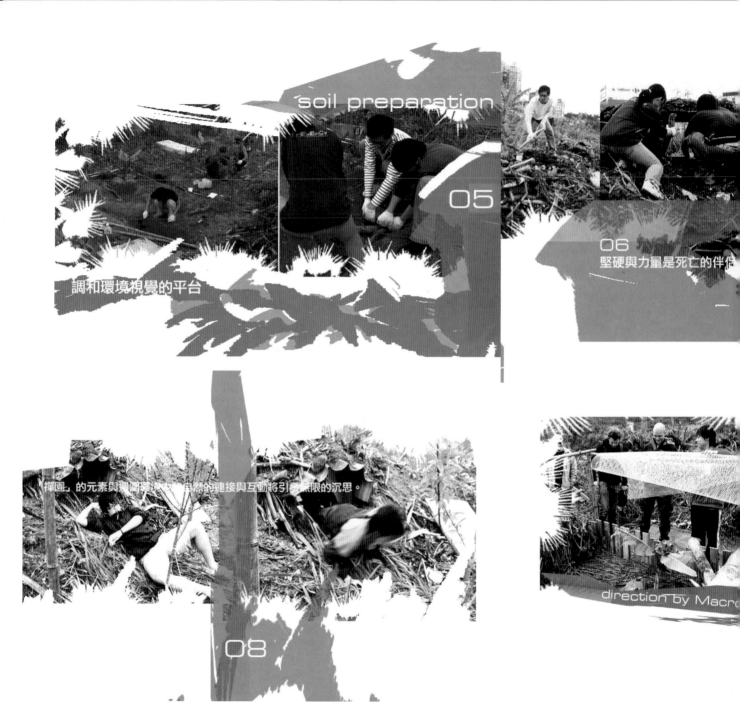

soil preparation

05

調和環境視覺的平台

06
堅硬與力量是死亡的伴侶

禪園」的元素與週間環境大自然的連接與互動將引發無限的沉思。

08

direction by Macr

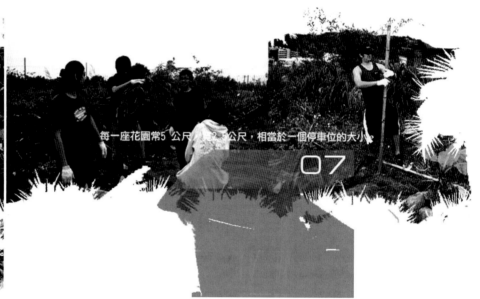

每一座花園常5 公尺，寬2.5公尺，相當於一個停車位的大小。

07

代表著新生。

ande /Hakan Rasmussen

-010

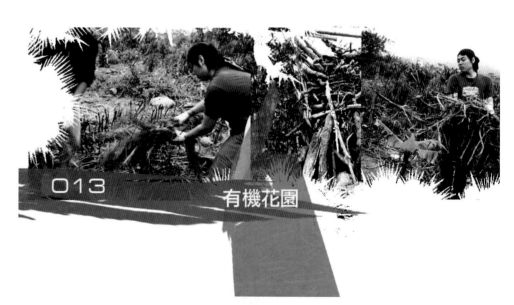

013

有機花園

06 / 澡堂禪園
/ The Zen Garden Bathhouse

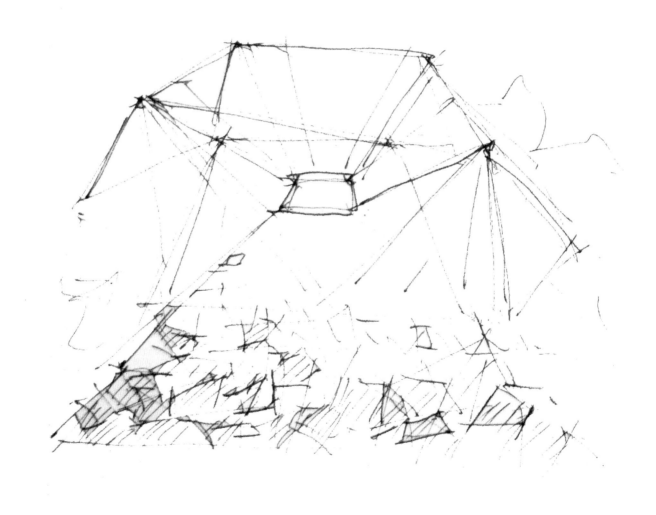

C Concept概念說明

澡堂禪園

　　是誰家裝潢浴室，而將拆除的舊浴室整個傾倒在大自然中？沒關係，讓我們就地取材，將廢棄的浴缸重新清洗埋入土中，將破碎的磁磚重新整理後鑲嵌在大地上，將周圍的雜草清除堆疊，將撿來的樹枝加以編織成為圍牆，於是就在這野地中創造出一座隱蔽的澡堂。天地為幕，不會有人發現的，到附近找一些山溝中的清水，躺下來洗個澡，輕鬆一下，萬物與我同在。

The Zen Garden Bathhouse

　　Who was dumping their old shower room into nature when remodeling their bathroom? That's okay, let's use what we found and wash and rebury the bathtub they threw out. We used and organized the broken tile pieces and made a mosaic on the land. Then we stacked up weeds, and weaved them with branches to make a wall, creating a hidden bathhouse out in the field. The sky is the ceiling, and the land is the ground. No one will notice it. Look for clear water from the ravine nearby, and lay back for a bath. Relax and enjoy, and everything is with you.

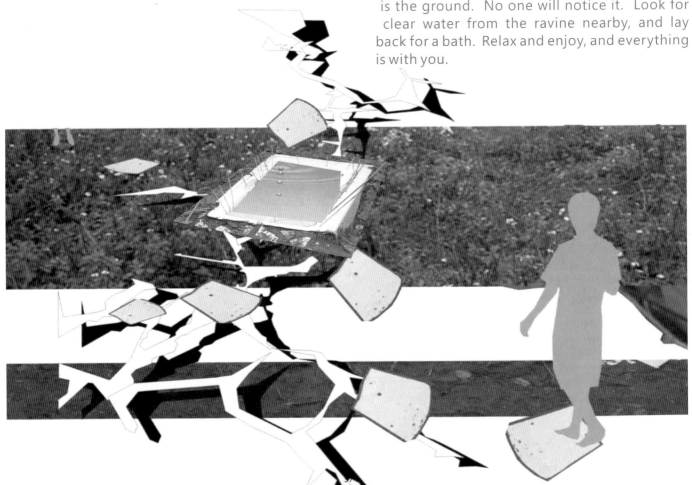

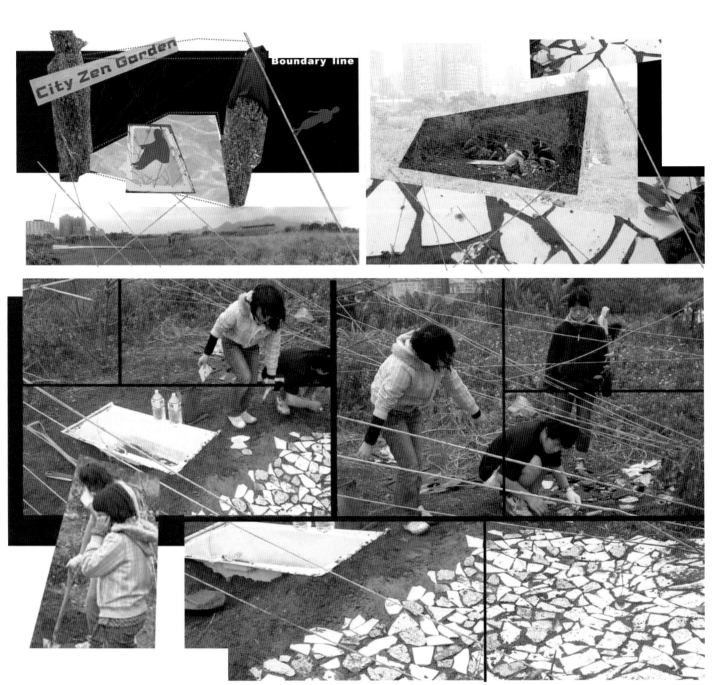

City Zen Garden

Boundary line

ZENGarden

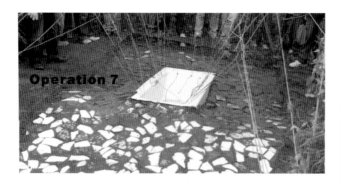

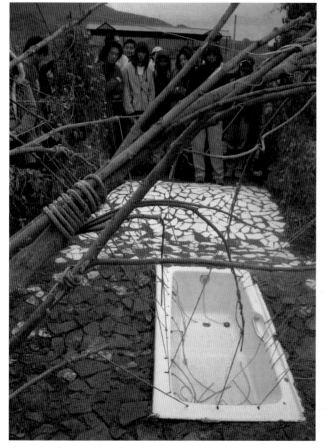

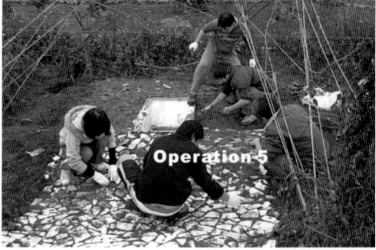

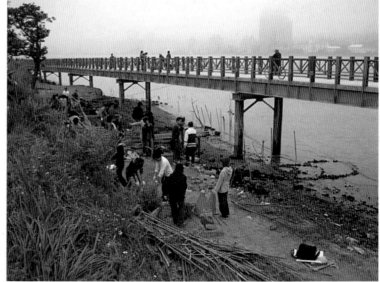

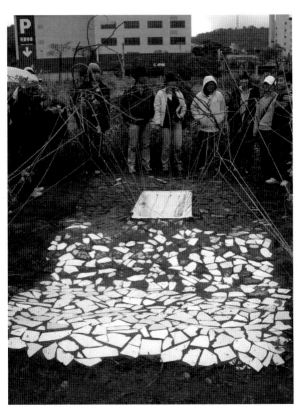

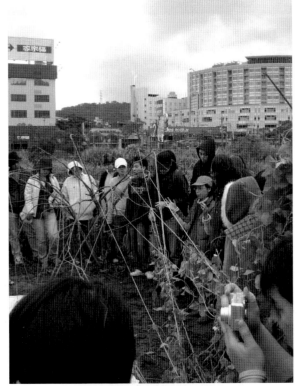

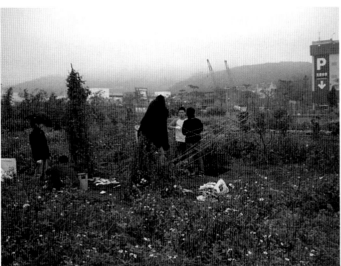

07 / 編織出的禪園
/ The Zen Garden by Weaving

C Concept概念說明

編織出的禪園

　　首先，我們在這自然地景中，不斷的來回觀察與摸索，最後選定一塊有半邊視野面臨一片樹林的草地作為基地。我們認為這塊基地的位置恰巧在樹林的正前方，可隔絕外界來的噪音，像是進入迷宮般的樹林，路徑也必須通過此基地。因此我們想藉由這些豐富的感官體驗（聲音、尺度、質感、高度、與位置等），延伸出一連串的設計概念。在這過程中，我們試圖在這片不到十三米見方的場域中，和自然產生對話。我們不斷的把土地往下挖，把所挖掘到的各類元素加以分類，嘗試著將這些原生地景的各類元素重新做個安排；並選定幾種具有特殊質感的材料，重新編織在這塊基地上，可以無拘無束隨性的或坐或躺，讓天地與我同在。

The Zen Garden by Weaving

　　First, we observed and explored the natural landscape back and forth, and finally we chose the site because of its half-view of some woods. We think the site just happens to be located in front of the woods. It's isolated from the noise from the outside, and entering the labyrinth of the woods requires a path through this site. Therefore, we wanted the rich sensory experiences (sound, measurement, quality, height and location, etc.) to be extended through a series of design concepts. Throughout the process, we tried to have a conversation with nature via this less than 13 meter square place. We continued to dig into the land, classified all kinds of materials, and tried to rearrange all the elements from the original landscape. We chose a few elements that had special texture, and weaving back to the site, you can sit or lay down very casually, letting heaven and earth be with you.

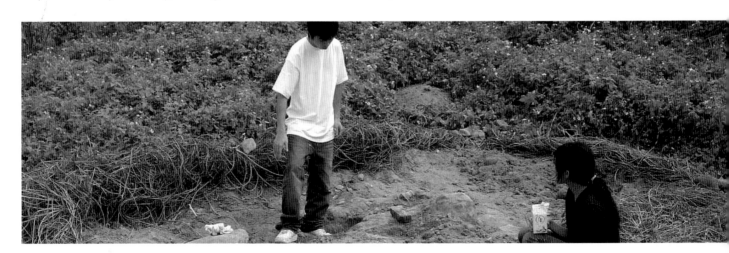

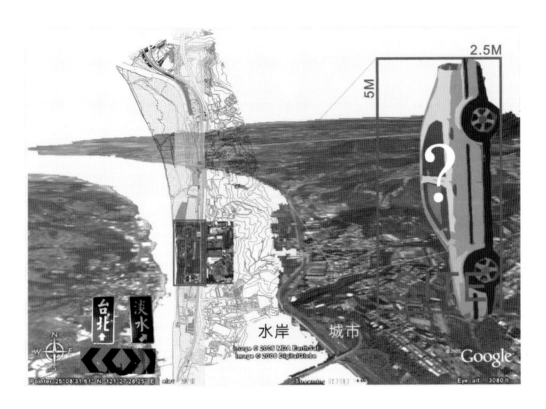

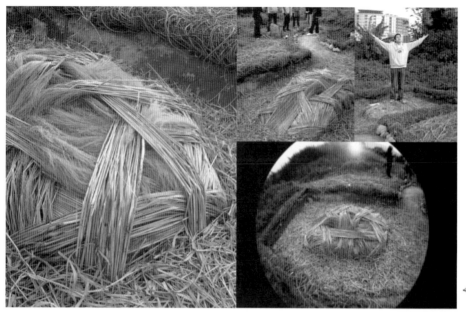

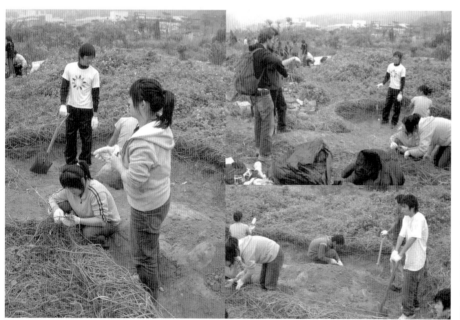

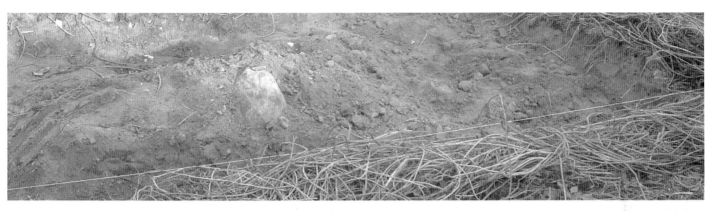

揀
Choice
02/24 DAY 2

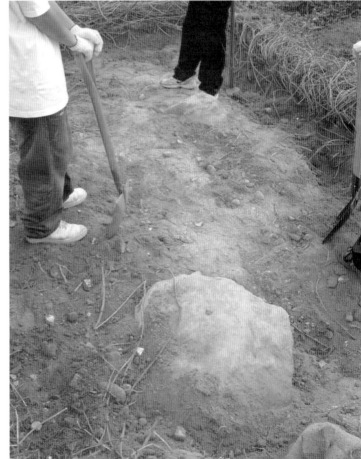

ZENGarden

08 / 由棄磚所堆砌的禪園
/ The Zen Garden Piled up with Abandoned Bricks

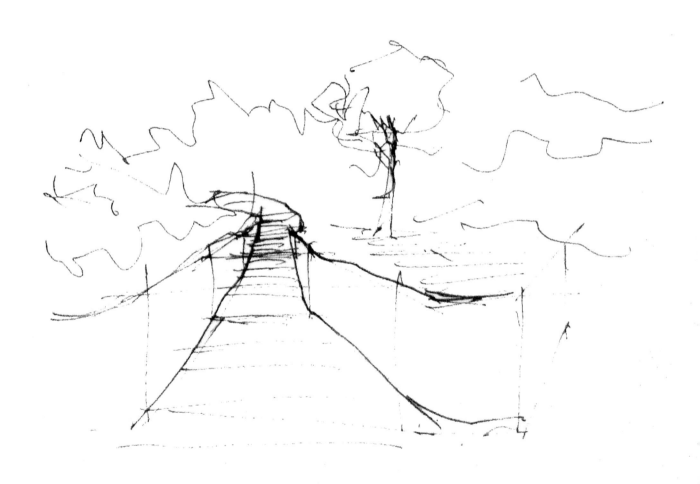

08組　徐昌志/郭思敏/蔡孟芬　張創霖 徐嘉豪 李能真 林昇漢 俞瑩 張印光 何佩璇 林庭婷 陳郁婷 陳維剛 張世麟

C Concept概念說明

由棄磚所堆砌的禪園

　　基地附近有「禁倒廢土」的牌子，但是到處可見傾倒的廢土。於是我們找到一堆棄磚，將這堆棄磚加以分類，其中有：破碎的水泥塊、磚塊、空心磚、石塊、與石板等。經過仔細的計算後，我們將這些廢棄的建材，重新堆砌出一座禪園。人們除了可以坐在重新堆砌出的矮牆上，一角有一座堆砌出的小山，這座小山有些日式「枯山水」的精神，小山中埋藏著一個「時空膠囊」，多年後我們可以重回禪園，開啟這埋藏的「時空膠囊」。

The Zen Garden Piled Up with Abandoned Bricks

　　There is a sign that says "Dumping waste soil is banned" near the site, but we still saw waste soil dumped all over the place. Then we found a pile of thrown out bricks. We classified these bricks, including broken cement blocks, bricks, hollow bricks, rocks and slates, etc. After careful calculations, we built up a Zen Garden with these waste building materials. People can sit on the rebuilt low wall, and there is a small hill in the corner, and the hill has the spirit of a Japanese dry garden. Within this hill we buried a time capsule, so we can come back to open the time capsule in this Zen Garden after many years.

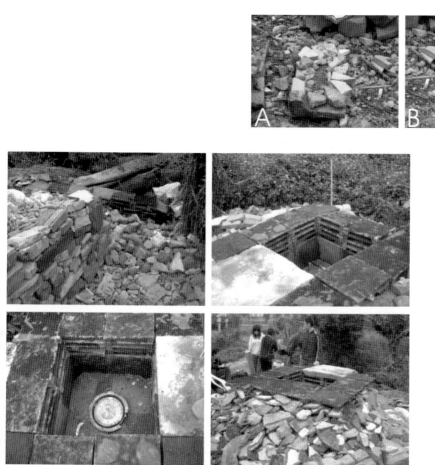

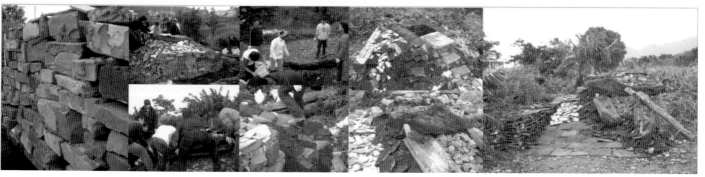

ZENGarden

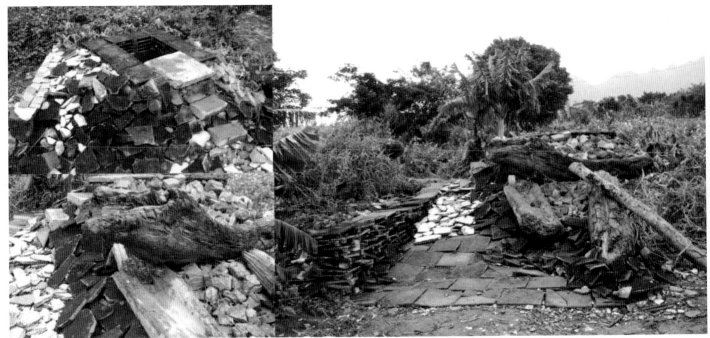

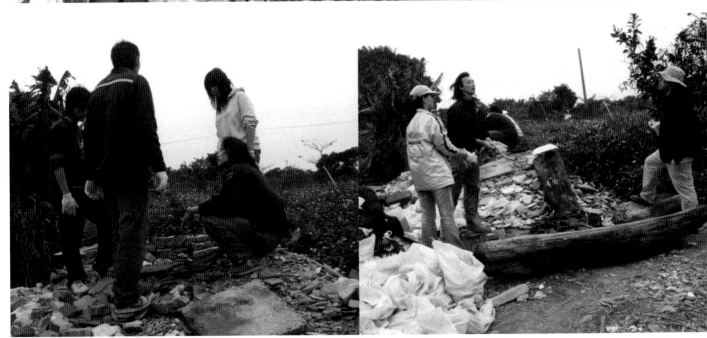

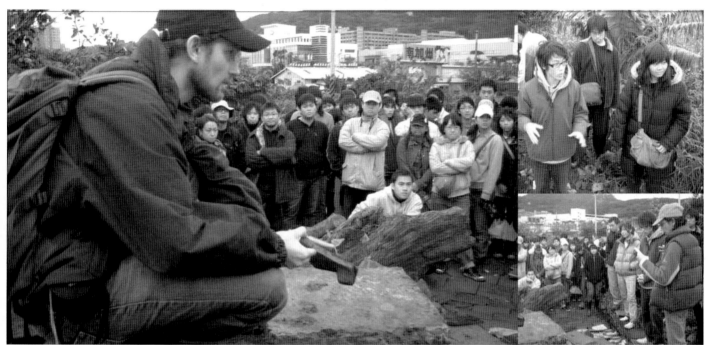

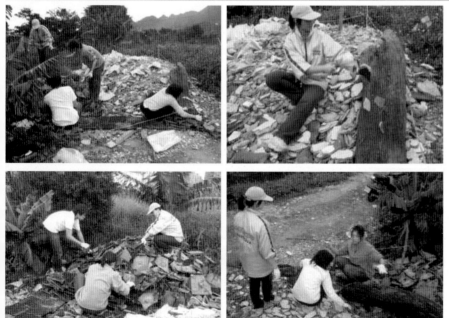

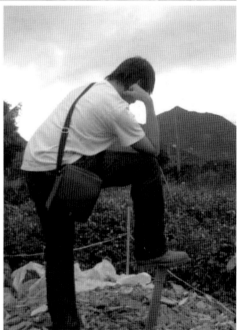

09 / 芒草叢中的禪園
/ The Zen Garden in Miscanthus Sinensis

09組　李盈芳 翁偉真 謝宛蓉 吳聿淇 陳逸珊 陳右昇 謝明軒 簡文煌 葉靜儀 謝仲凱 劉筑甄

C Concept概念說明

芒草叢中的禪園

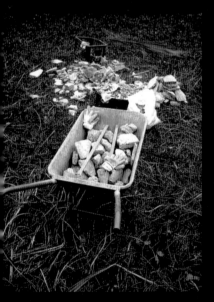

　　基地位於長滿高過一個人的芒草叢中，芒草叢的範圍非常的廣大。首先在芒草原中開闢出可容一人通過的蜿蜒小徑，長約30公尺。在蜿蜒小徑的終點，開闢出一個直徑寬約5公尺的圓形禪園，地上舖滿了由附近撿來的破碎小水泥塊，正中間挖了一個小洞，小洞上方放著一個撿來的舊鍋子，鍋子裡放著一堆柴火，於是就可以在此生火。當坐在地上的撿來的老樹幹上時，周圍高高的芒草將這禪園隱藏於不易被人發現的芒草叢中，別有洞天。

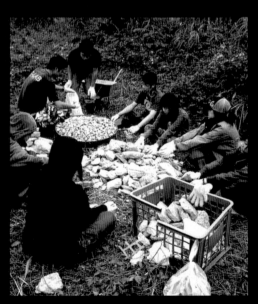

The Zen Garden in Miscanthus Sinensis

The site is located in an area covered with Miscanthus Sinensis, which is taller than a person. The range of the Miscanthus Sinensis is quite wide. First, we made a one-person wide winding path in the field. It's about 30 meters long. At the end of this winding path, we built a round shaped Zen Garden with about a 5 meter wide diameter. We covered the ground with broken cement pieces from nearby, and dug a small hall in the middle. Then we placed an old pot picked up from nearby, and we put some firewood in the pot, so we can start a fire there. When we sat on the old picked up tree trunk, the tall Miscanthus Sinensis hid the Zen Garden within, making it difficult to find.

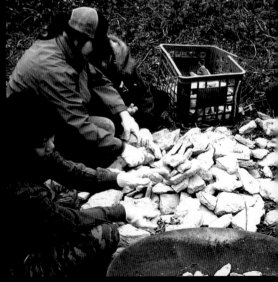

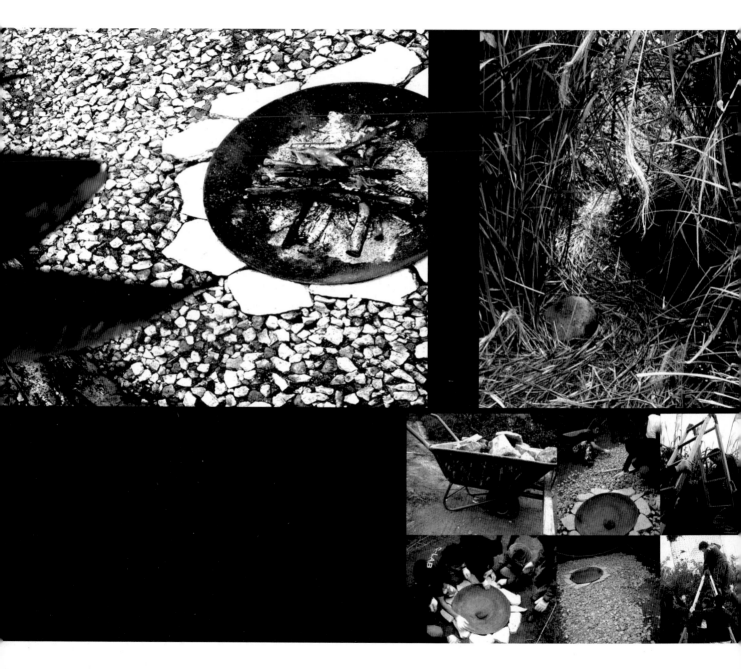

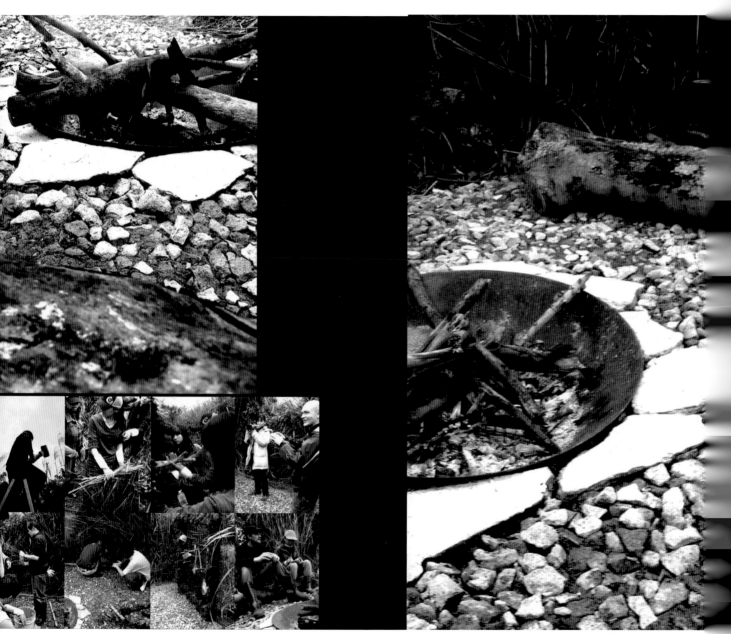

ZENG

10 ／ 竹籬中的禪園
／ Zen Garden in a Bamboo Fence

10組　黃瑞茂　陳英男　何銘瑋　楊雅玲　吳訓漩　吳明玄　鄭宇晴　羅若瑋　柯濬彥　陳騰輝　邱彥勳　鄭明輝

C Concept概念說明

竹籬中的禪園

　　將場地重新舖上附近撿拾來的石塊，並將撿來的竹子剖開編織成圍籬，然後將場地中乾枯的野草與樹枝穿插於圍籬中，佈置成一小型的鄰家花園。由河岸邊的自行車橋上，可以俯瞰這一小型的河邊花園。

Zen Garden in a Bamboo Fence

　　We laid out the picked up rocks from nearby the site, and weaved the picked up bamboo into a fence. Then we interspersed dry grass and twigs into the fence, and arranged a small garden next door. You can overlook this small riverside park from the bicycle bridge by the riverbank.

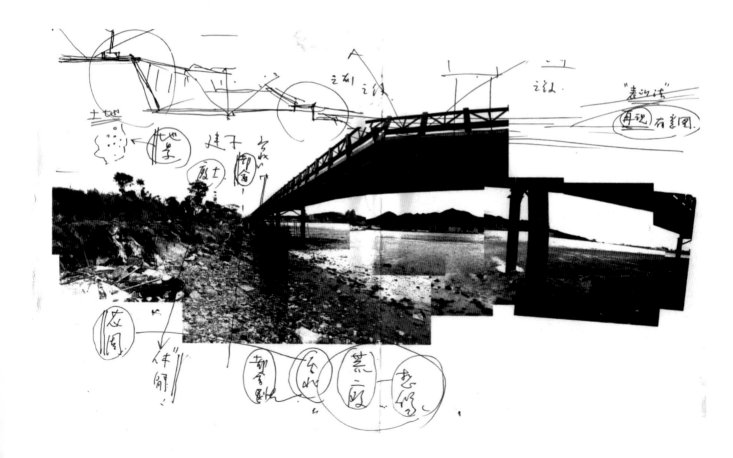

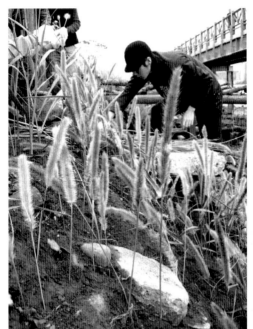
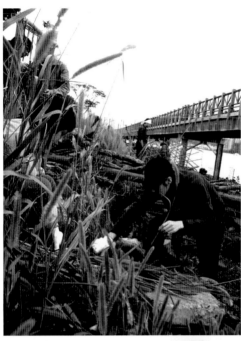
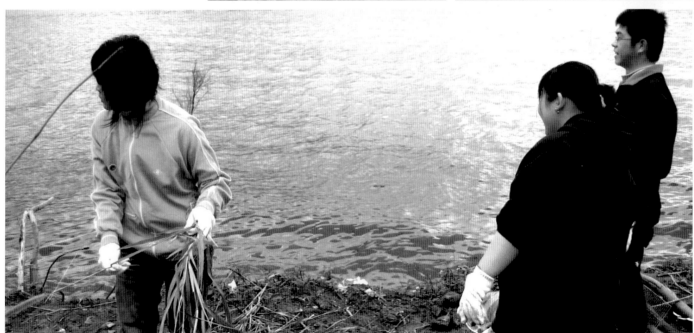

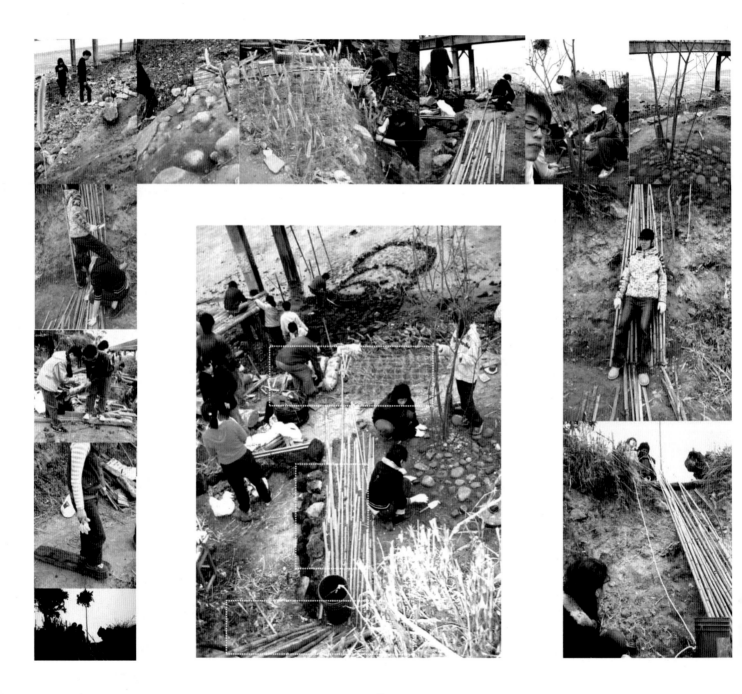

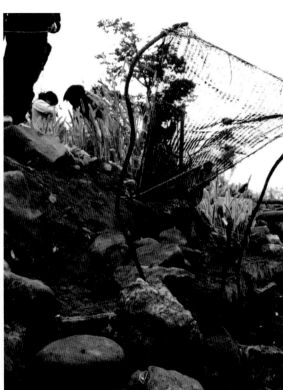
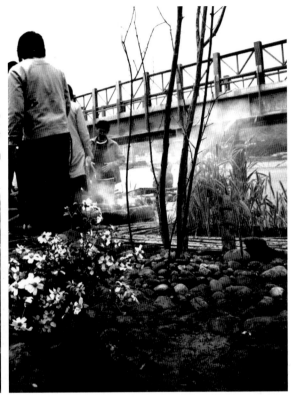
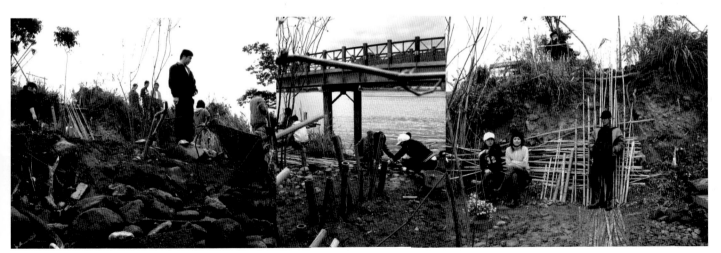

11 / 枯與榮的禪園
/ The Withered and Thriving Zen Garden

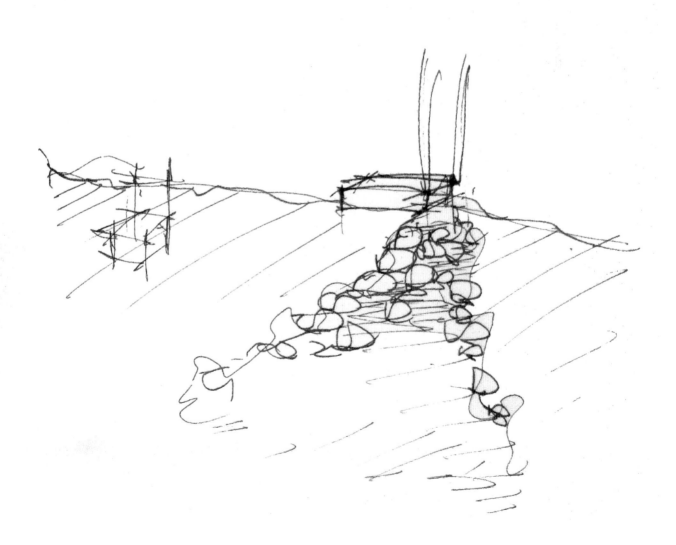

Z 城市禪園工作營 CITY ZEN GARDEN

11組　曹羅羿 王芊文 王祈雅 吳怡宏 黃國華 林與欣 周佑亮 鍾業敏 陳德凡 蔡宗佑

C Concept 概念說明

枯與榮的禪園

　　在泥濘的河邊，我們先將場地中的水瀝乾。然後將附近所檢到的的枯樹枝、枯木、與石頭仿照日式「枯山水」的風格創造半個禪園。另外，半個禪園則是找尋附近適當的植物，例如：小樹、小灌木、與芒草重新種植。半個枯山水禪園與另外半個生機盎然的禪園互相參照，可以讓我們重新反省自然的生與死，並思考對於生態的態度。

The Withered and Thriving Zen Garden

　　By the muddy riverside, we drained the water out of the location. And then we created a half Zen Garden in the "Dry Garden" style by using picked up dry branches, dead wood and stones. The other half of the Zen Garden was made by finding the appropriate plants, such as little trees, little bushes and Miscanthus Sinensis. The half dry Zen Garden cross referenced with the other half, filled with vitality, lets us reflect on the life and death of nature and think about ecological approaches.

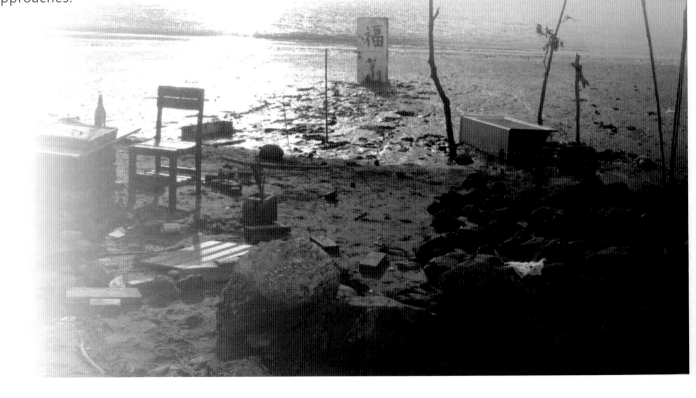

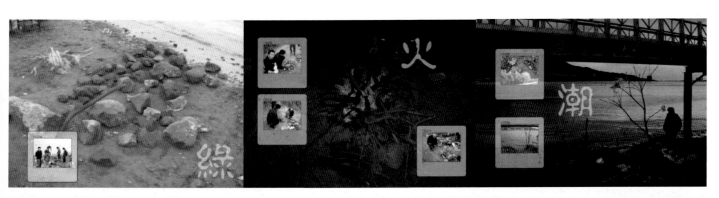

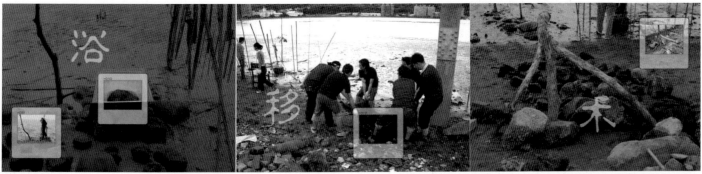

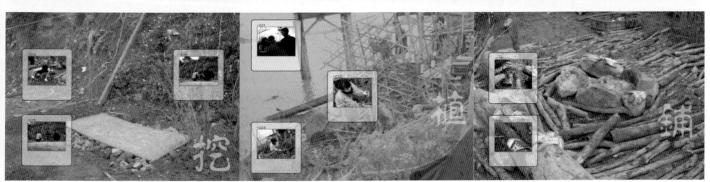

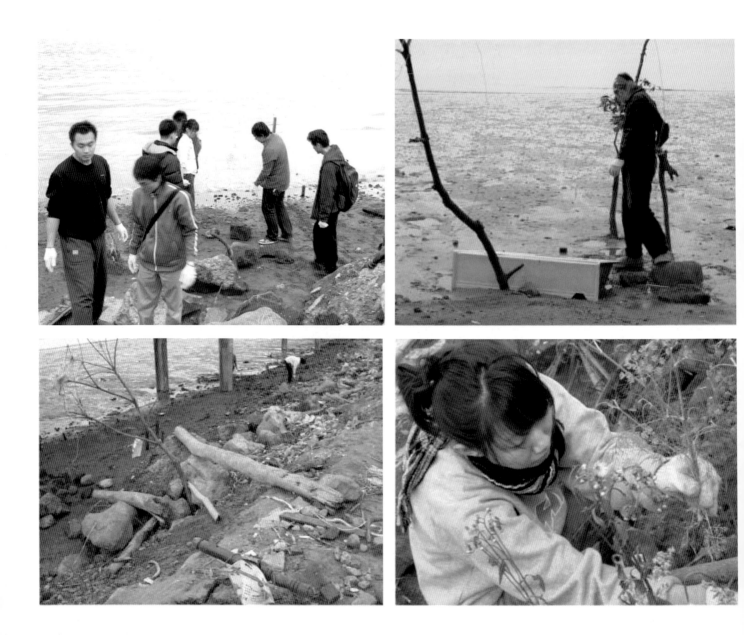

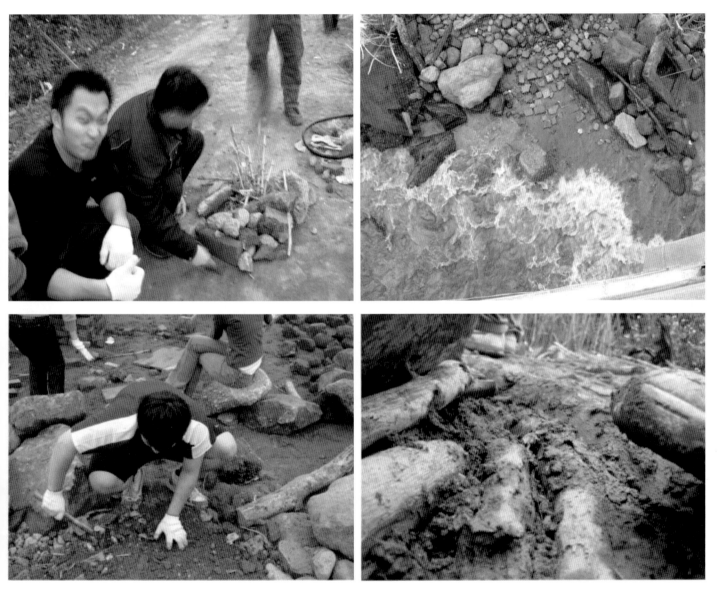

ZENGarden

12 / 風聲中的禪園
/ The Zen Garden in the Voice of the Wind

C Concept概念說明

風聲中的禪園

　　在基地附近撿到許多被丟棄的竹子、鐵絲、與瓶子，於是我們就拿這些廢棄物廢物利用。我們的基地正好位於下風處的山坡上，於是我們開闢的一段下坡的階梯，舖上了竹片以防止滑倒，拉上了繩子當做下階梯用的扶手。繩子上掛著竹片、鐵絲、與瓶子，當微風吹過，或人們扶著繩子下坡，就可以聽到聲響瀰漫在寧靜的荒地之中。

The Zen Garden in the Voice of the Wind

　　We found a lot of abandoned bamboo, wires and bottles, and we reused this waste. Our site is located at the lower downwind part of the hill, so we created a ladder to go down the hill. We covered it with the bamboo to prevent slipping, and used rope as the handrail to go down the ladder. Bamboo pieces, wires and bottles are hung from the rope, and as the wind goes by, or when people go downhill and hold on to the rope, you can hear the sound widespread in this peaceful wasteland.

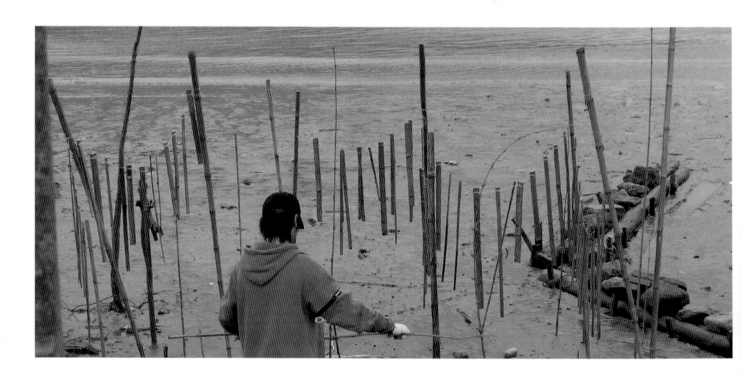

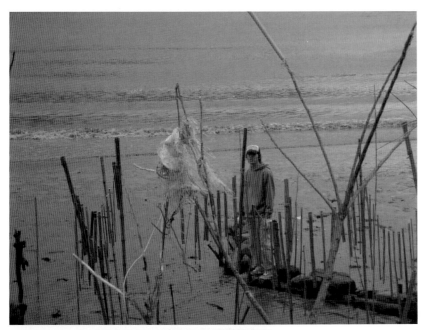

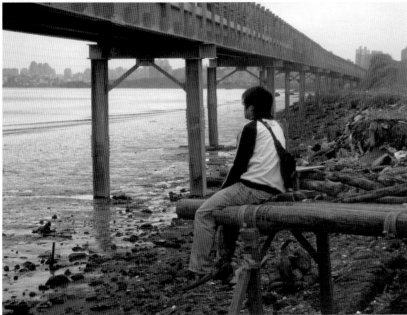

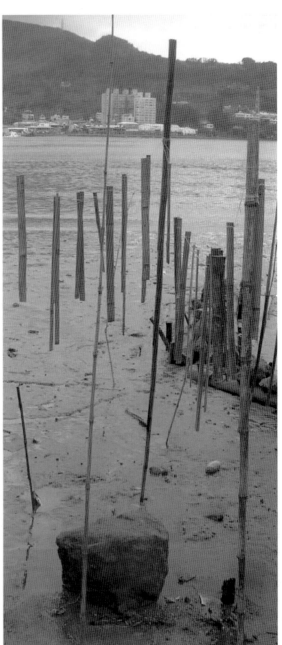

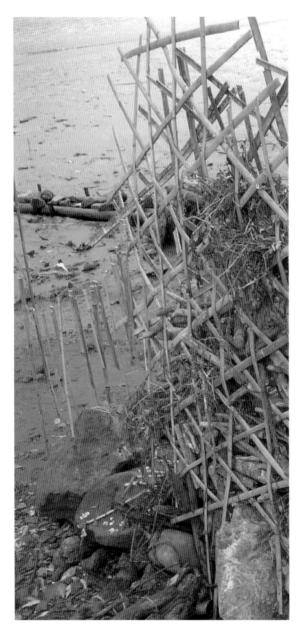
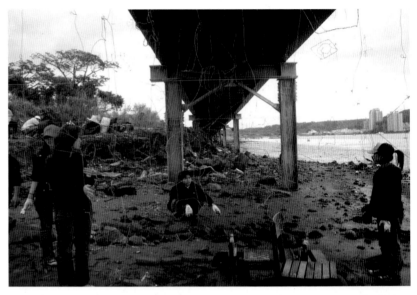
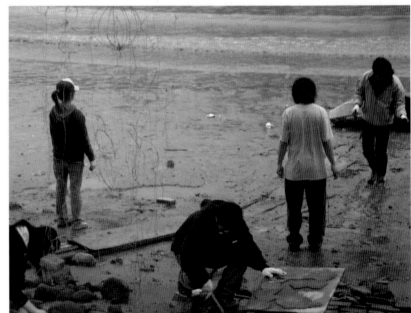

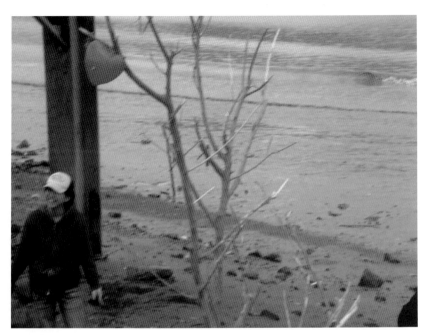

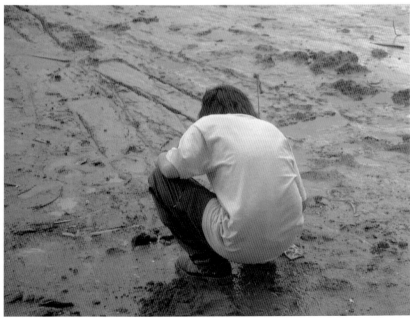

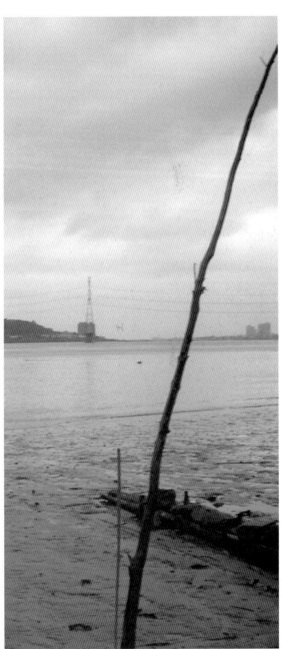

13 / 挖土後又填土的禪園
/ The Zen Garden by Digging and Refilling the Earth

C Concept概念說明

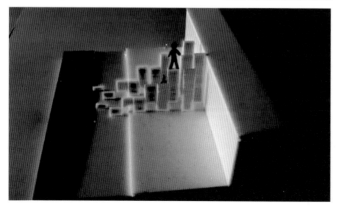

挖土後又填土的禪園

　　我們一開始想做的設計比較複雜，想應用具有反光材質的門，反射基地較高處與較低處視野的不同。後來在討論的過程中，我們發現到想的事情太過於複雜，不太符合「禪」的精神。同時，我們也開始在基地上做一些挖掘，我們發現土壤中混雜著人們所丟棄的廢物。所以我們想將整個設計簡化，之後，我們做的事情很簡單，將土壤下挖約50公分，然後將土壤中的人造物雜質篩選出來，成為純粹的泥土，然後再將這些泥土放回大地，完成我們身體力行的工作，藉由身體的行動來完成頭腦的思考。

The Zen Garden by Digging and Refilling the Earth

　　We started out this complicated design wanting to use a door with a light reflecting material, to reflect the different views of the higher and lower parts of the site. But then throughout our discussions, we realized this was just too complicated, and would not fit the "Zen" spirit. At the same time, we started to dig into the site, and we found that the soil was mixed with waste from people. So we simplified the whole design. After that, what we did was very simple. We dug in about 50 centimeters, and filtered the human impurities from the soil so it became just soil. Then we placed the soil back onto the land, and completed the physical work. We were able to complete our thought process through the physical labor.

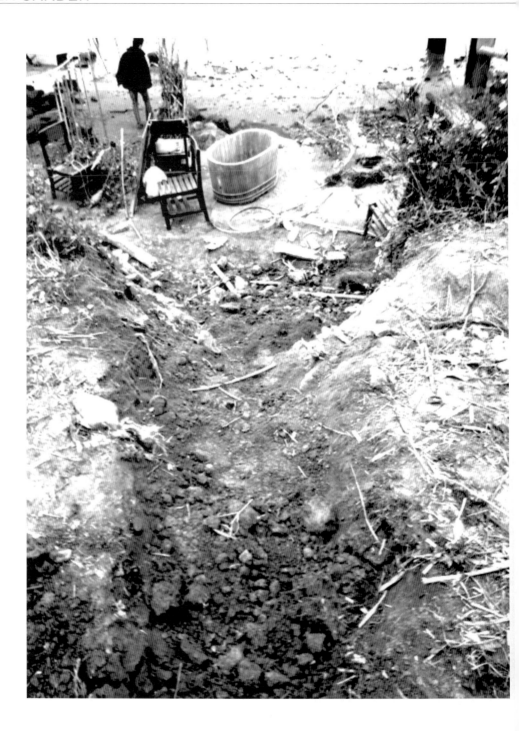

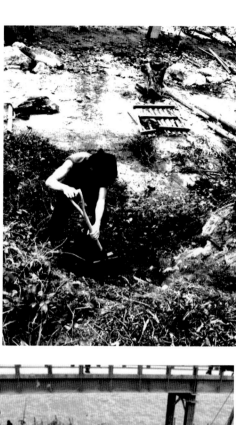

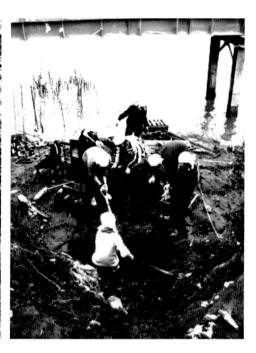

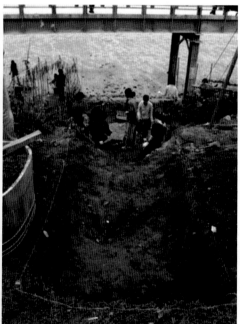

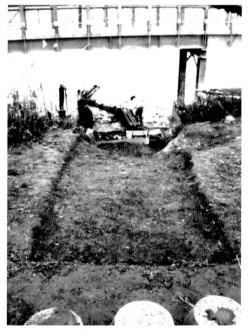

14 / 三角形禪園
/ The Triangular Zen Garden

C Concept概念說明

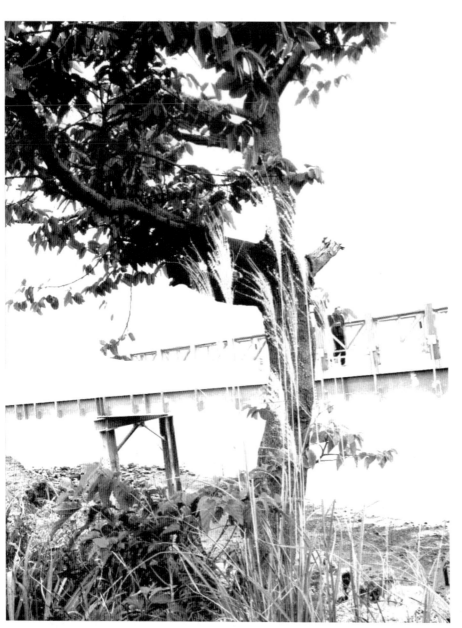

三角形禪園

我們的動作很簡單，在小山坡上開闢了一條往下的台階與一條往上的坡道，台階鋪上撿拾來的碎石塊，坡道則未做任何處理，保持挖掘後的真實狀態。台階與坡道間自然形成一個三角形坡地，我們在這三角形坡地重新種植上整齊的芒草，形成一種人工化的自然，上下小山坡的人們，可以透過芒草叢若隱若現的看到對面的人們。

The Triangular Zen Garden

We started with a simple task , and built rails going downwards from the hill, and we built a ramp going upwards. The rails were covered with little rocks that we picked up from nearby, but we kept nothing on the ramp in order for it to look realistic after excavation. The rails and the ramp naturally form into the look of a triangular hill. We re-planted and organized Miscanthus Sinensis onto this triangular hill, giving an artificially natural look. The people coming up and down the hill can actually see each other through the see-through Miscanthus Sinensis.

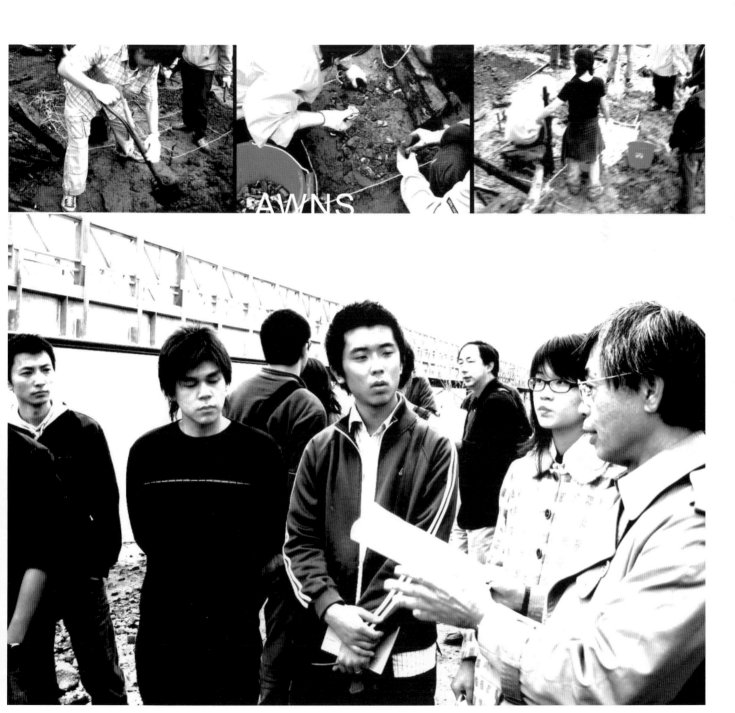

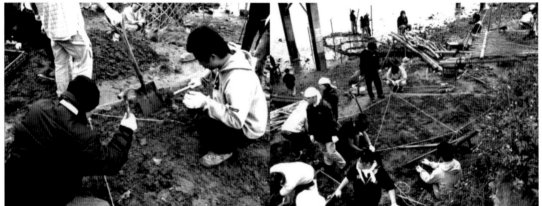

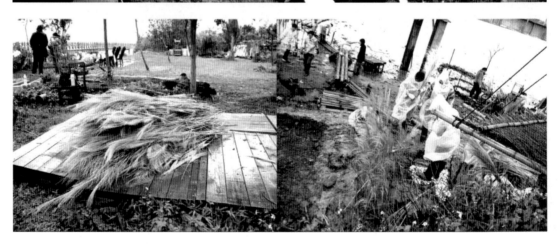

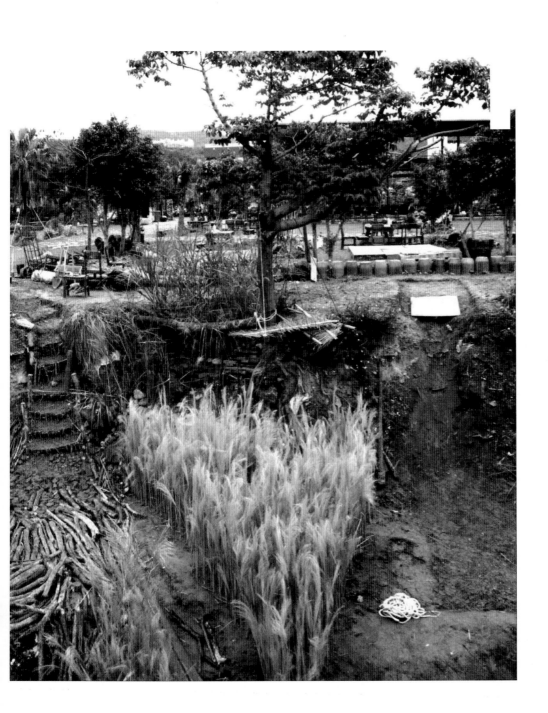

15 / 河聲禪園
/ The Zen Garden with the Sound of the River

C Concept概念說明

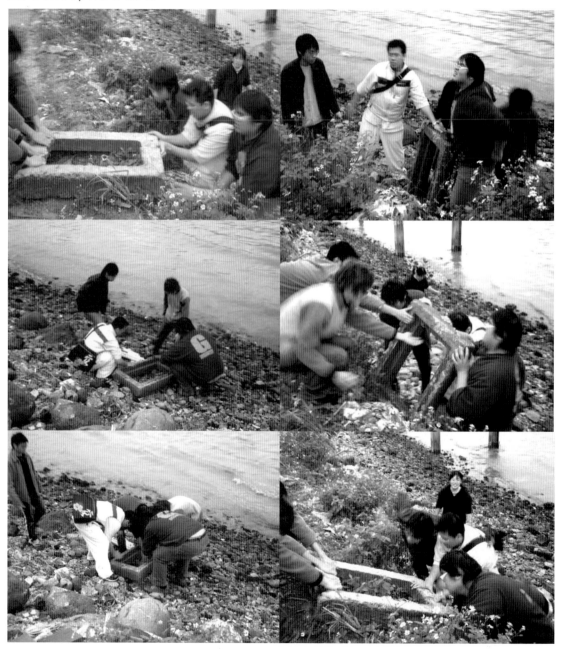

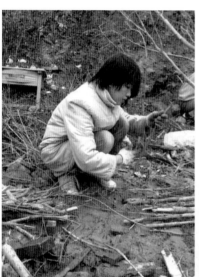

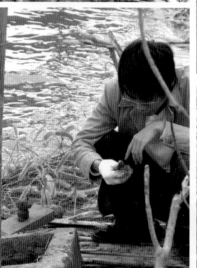

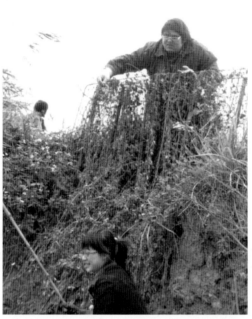

河聲禪園

　　坐在寧靜的河邊聽河流的聲音，是一件非常愜意的事情。我們撿拾了附近的廢棄磚頭，堆砌成一座寬約一公尺見方的方形座椅區，另外以石頭在河中堆砌起三個縮小的圓形石滬（石滬是淡水有名的傳統捕魚裝置），中間以舖上石頭的小徑連結。坐在方型的矮座椅上，可以去冥想河中圓形石滬裡波動的狀態，並傾聽河水流動的聲音。

The Zen Garden with the Sound of the River

　　It can be a very comfortable thing if you sit by a calm river and listen to the sound of the flowing water. We picked up the thrown out bricks, and built them up as a meter square wide sitting area. In addition, we built three mini round rock ponds (using rock ponds is a traditional way of catching fish in Tamsui) in the river, with tiny, rock-covered rails connecting them. Sitting on the low, square seat, we can meditate about the fluctuations in state of the rock ponds, and listen to the sound of the water going by in the river.

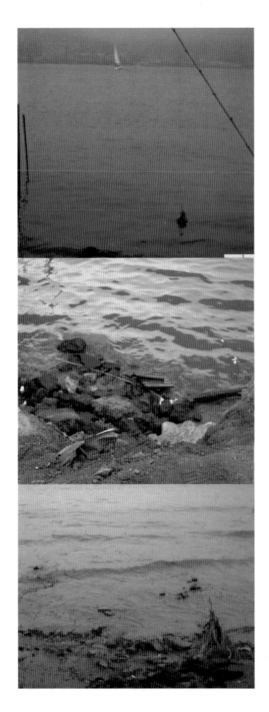
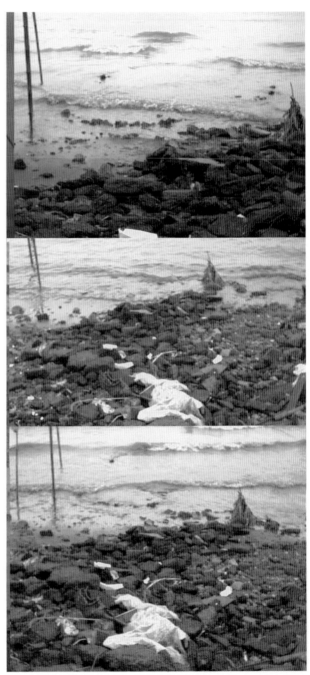

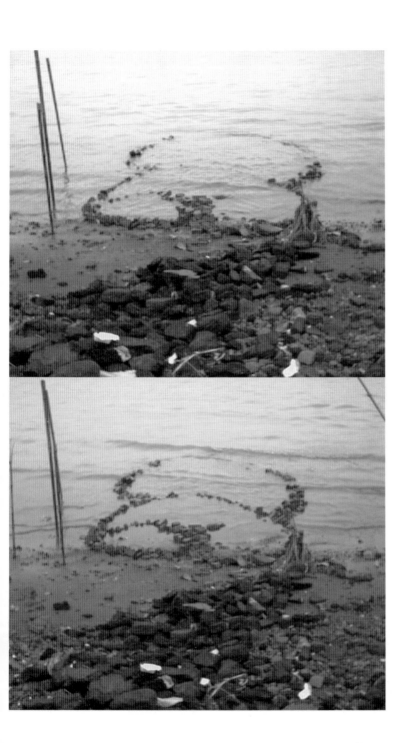

16 / 漂流木禪園
/ The Driftwood Zen Garden

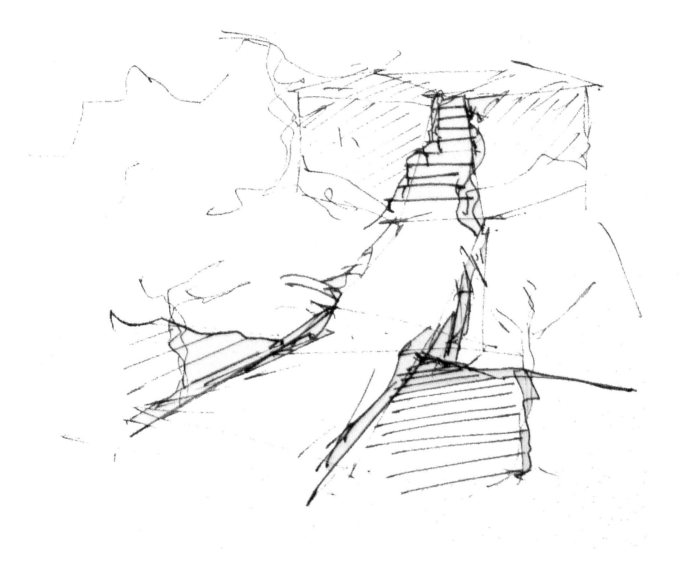

16組　張恭領　　李孟浩　蔡孟寰　謝佩芳　張文睿　吳介元　保　琳　李怡瑩　陳志昇　歐湛瑜　陶　珩

C Concept概念說明

漂流木禪園

　　沿著河岸行走，可以發現到許多淡水河上游漂來的漂流木，基地附近遺留著一棟老屋拆除後的廢棄建材：磚頭與木材。我們希望引導人們從河邊的小山坡上走向河邊，為了解決小山坡與河邊高低差的問題，於是我們在小山坡上開闢一道階梯，階梯的尾端有一條步道與平台銜接至河邊，形成一條通道。撿拾來的磚頭成為泥濘通道的舖面，磚頭上舖著漂流木，舖設的紋路順著通道往河邊的方向，而撿拾來的木材搭設成通往河邊的小型平台。

The Driftwood Zen Garden

　　Walking along the riverbank, we found a lot of driftwood that had been taken down the Tamsui River. We found waste bricks and wood by an abandoned old house near the site. We hoped to guide people from the hill to the riverbank, and we tried to solve the height difference between the river and the hill, so we built a rail up the hill. There is a trail and a platform connected to the end of the rail, becoming a passage. The bricks that we picked up became the pavement for this muddy passage. The bricks were covered with driftwood, and the pattern of lines goes smoothly toward the river. The wood that we had picked up built a small platform that goes toward the river as well.

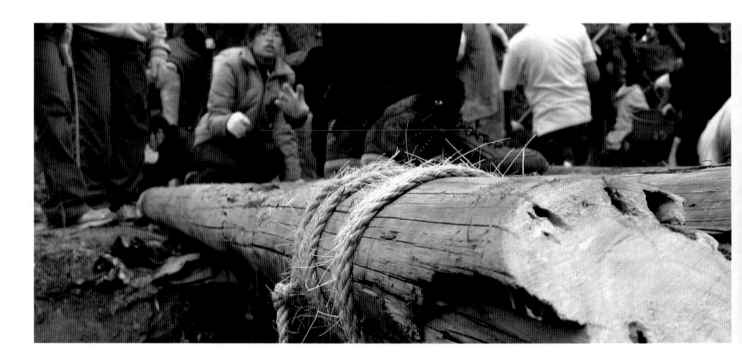

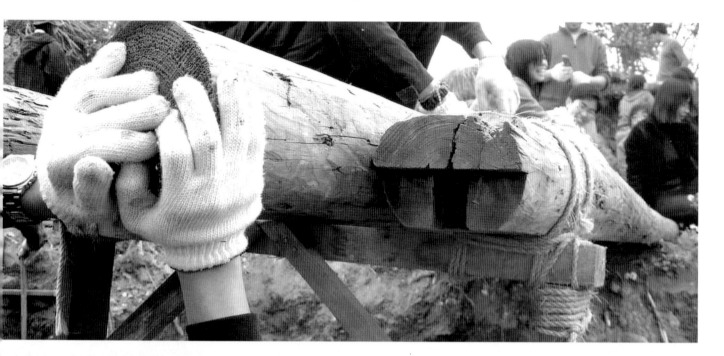

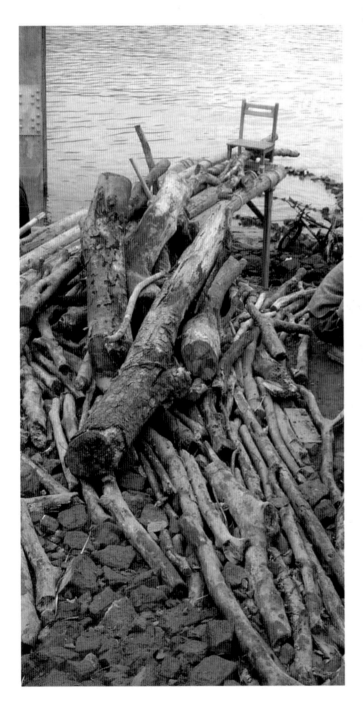
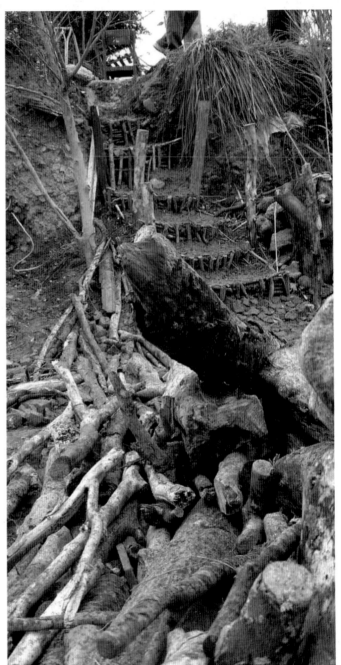

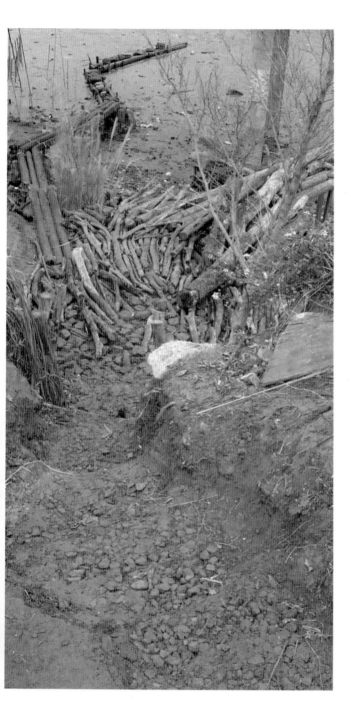

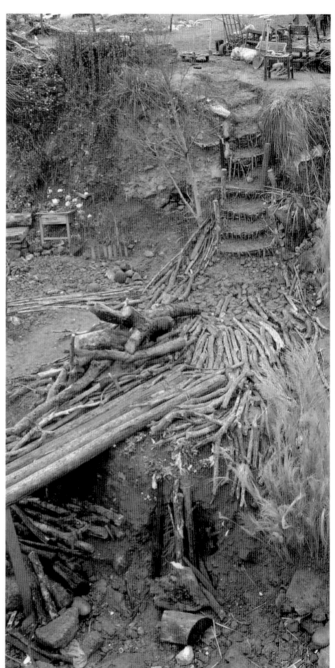

17 / 河中的禪園
/ The Zen Garden in the River

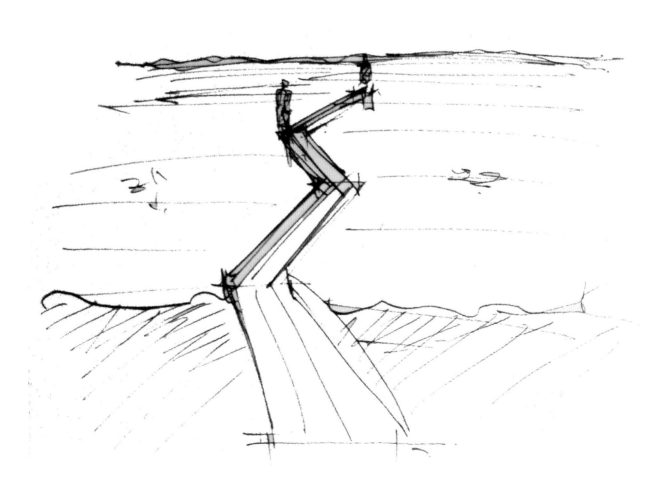

C Concept概念說明

河中的禪園

　　我們想延續前一組（第16組）的「漂流木禪園」，將人們再往前延伸至河流中央。我們將撿拾來長形樹幹綁在一起形成棧道。這些棧道可以連接起附近的三組禪園，潮間帶的河水在漲潮時會將部份的棧道淹沒，不同的時間到達河邊，可以到達的地點將會有所不同，因此也可以體會到河流潮間的變化。

The Zen Garden in the River

　　We wanted to continue "The Driftwood Zen Garden," and bring people to the center of the river. We tied a long tree trunk that we picked up into a plank road. And this plank road connected the three Zen Gardens nearby. The river covers part of the plank road when it's high tide, so you can go to different locations because of the different time you get to the river, and you can experience the tides of the river.

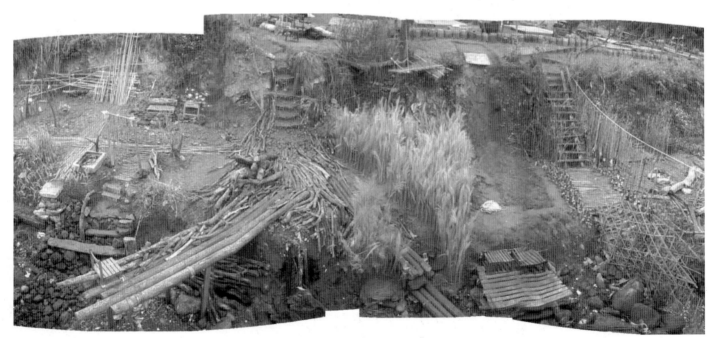

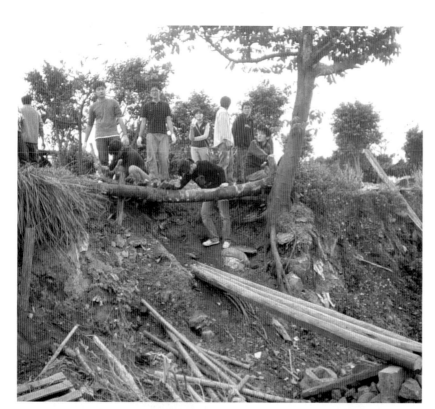
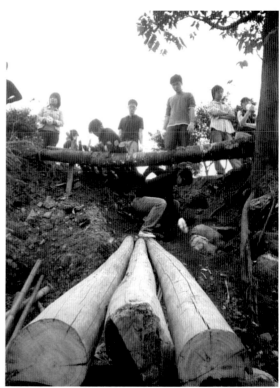
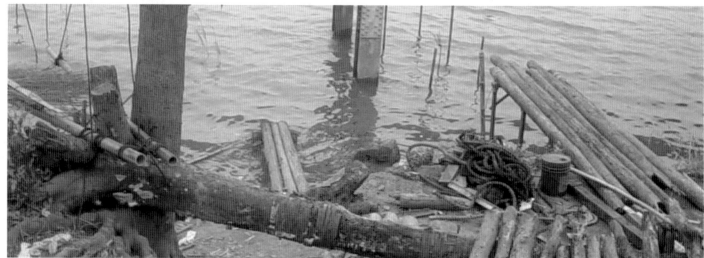

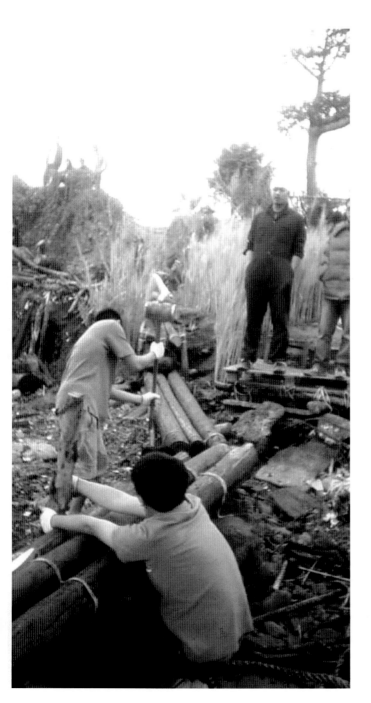

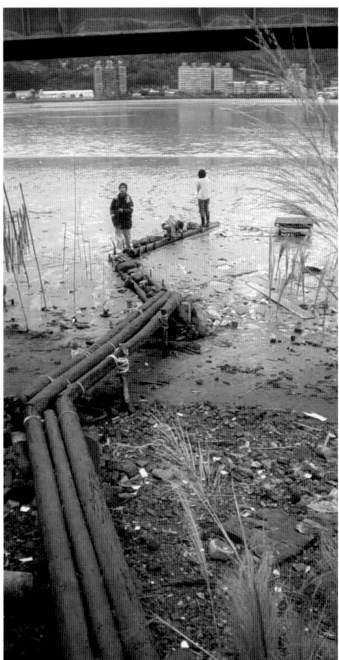

18 / 福門禪園
/ The Zen Garden of Fortune

C Concept概念說明

福門禪園

　　很意外的我們撿到一扇被丟棄的白色門，上面寫著一個大大的「福」字，這就是我們庭院的大門。我們將這一扇門下部四分之一埋入河邊的爛泥巴中，門會隨著潮水的起落，而顯現出不同的比例。在岸邊我們佈置了一個小花園，坐在小花園裡，淡水河、對岸的八里與觀音山也成為我們庭園的一部份，有些中國庭園「借景」的設計手法在其中。

The Zen Garden of Fortune

We unexpectedly found an abandoned white door with a big character in Chinese that says "Fortune." This is our door for the garden. We buried a quarter part of the door into the mud by the river, and the door will show different portions because of the tides of the river. We decorated a small garden by the riverbank, and the view of Tamsui River, Bali and Guanyin Mountain become a part of our little garden. That is the "Borrowed Scenery" design style from Chinese Gardening.

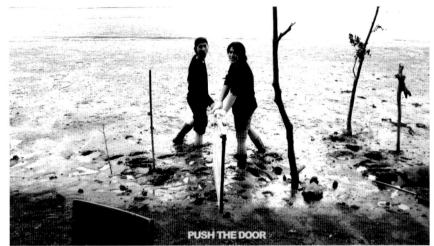

PUSH THE DOOR

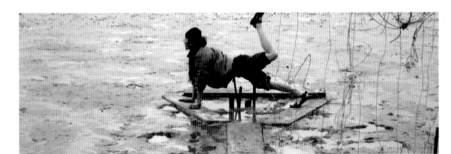

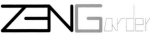

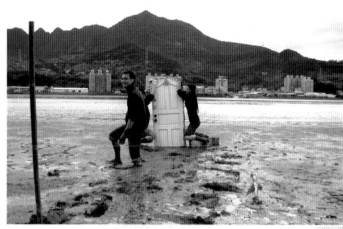

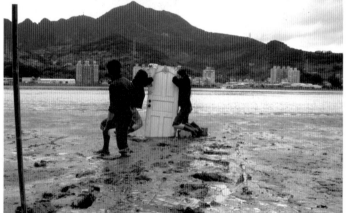

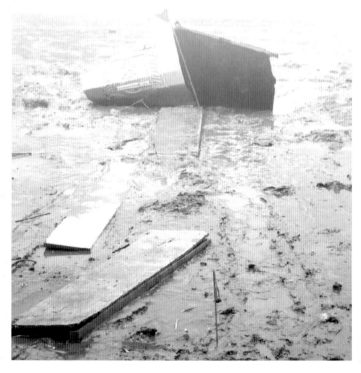

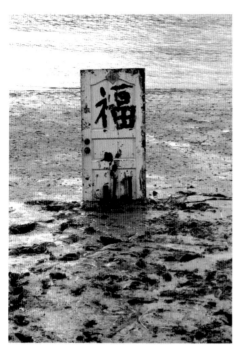

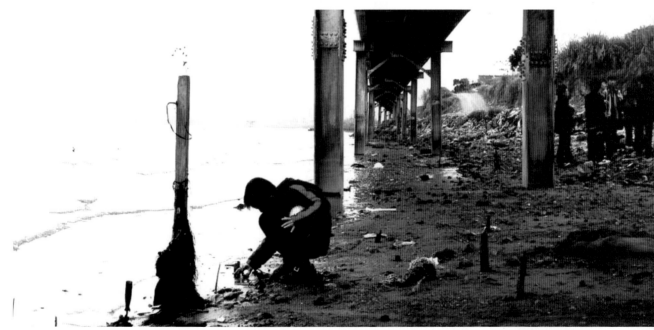

淡江大學建築系國際設計工作營

城市「禪」園工作營後記

　　為了加強學生的國際視野，從2003年開始淡江大學建築系每年在春天開始的時候會舉辦一次國際工作營。另外一方面，希望透過跨年級的編組，讓各年級的學生能夠認識不同年級的同學，同時也達到高年級同學帶動低年級同學學習的一種教學編組。2003年我們邀請了英國非常重要的前衛建築團體Archigram蒞校主持了主題為「Did you realize you were wearing your closet？」的工作營；2004年由日本的知名後現代建築師相田武文（Takefumi Aida）先生主持了「我希望設計這樣的淡水小鎮」的工作營；2005年由日本的知名數位建築（Digital Architecture）建築師渡邊誠（Makoto Sei Watanabe）先生主持了「分散／集中」的工作營。

　　我們基於前三年的經驗，經過與學生與老師的討論後，我們決定這回要到戶外，做一些身體力行的設計與施工。國際工作營的主持人和我們的芬蘭籍客座教授卡馬可（Macro Casagrande）先生討論之後，我們決定邀請挪威知名的建築團體3RW Architects的成員之一河康（Haakon Rasmussen）先生與卡馬可教授共同來主持工作營，很高興的河康先生欣然答應，遠從千里之外挪威的奧斯陸來到淡水主持這個工作營。

　　此國際工作營主題由卡馬可教授策劃，主題是「城市禪園」（City Zen Garden）。原則上每一組學生得實地建造一座5.0公尺長，2.5公尺寬約一個車位大小的「禪園」。這次的工作營採自由報名參加的方式，參加的同學非常的踴躍，計有研究所一年級學生22名，他們同時是各組的助教；另外有大四學生55位、大三學生43位、大二學生4位、與大一學生66位，一共190位，我們將這些學生分成了18組，除了建築系的專兼任老師之外，我們邀請了幾位研究所已經畢業的學長回來共襄盛舉，擔任各組的指導老師。

　　2006年2月22日，河康先生抵達淡水的第二天，在微雨中我們先勘查了工作營的場地，並且在工作營基地旁的土地公廟拜拜，祈求往後幾天工作營進行順利。因為根據台灣人的習俗，工程開始進行時，都得敬天地，後來果真工作營進行的十分順利。

　　2月23日早上，在河康先生演講「the Cultivating Man - Participation in Landscape」，午餐之後我們這一群200人浩浩蕩蕩的從系館出發，大部份學生都騎著摩托車到達距離學校約15分鐘車程的基地。基地位於竹圍捷運站的後方，介於淡水河和台北捷運淡水線的軌道之間，經過系上黃瑞茂教授與當時研究所二年級洪金江同學與當地農民的溝通後，免費提供我們使用這個場地。經過討論後，河康教授所帶領的九組（01-09組），在靠北邊的荒地上進行城市禪園的設計；卡馬可教授所帶領的九組（10-18組），在靠南邊的河邊潮間帶上工作，遙望著觀音山。

　　整個工作營從23日下午進行到27日中午，大約有四整天的時間，並於27日下午進行最後的設計講評。一開始和同學討論完後就決定各組不應該花任何錢，所以大家都得遵守這個設計規則。第一個工作天，各組開始找尋適當的「禪園」位置，然後進行整地的工作，這時候各組已經隱隱約約發現了不同「禪園」的訴求主題。比方說：同學們除完草後，一鏟一鏟的往下挖，可能是碎石，也可能是直徑超過30公分以上的大塊石頭，或者是雜草堆中竟然是民眾任意傾倒拆屋之後的廢棄物，或者是河邊的同學得與潮汐抗爭。這些都是在學校的工作室做紙上設計作業時，所無法經

驗到的實際基地挑戰，因此同學們都得一邊施工一邊更改設計，這是大家始料所未及的，也是嶄新的一種設計經驗。感謝劉綺文老師的翻譯，讓有些英文不是那麼靈光的同學，可以完全了解到兩位外國老師的建議。

　　那幾天總是下著小雨，但是同學們總是興致勃勃，光著腳丫或是穿著長筒雨鞋，穿著簡單的雨衣，在泥土上工作著，活像河康老師的演講主題－「耕作人」。也感謝畢光建、王俊雄、與蘇睿弼教授擔任總指揮，讓整個工作營進行的非常順利，完全沒有同學受傷的情形發生。

　　經過四天的努力，各組的成果收及在這本小冊中，這個工作營之後同學們認為有幾點非常重要的意義：一、基地對於同學而言是具有生命力的，是設計創作的泉源；二、身體力行原來是設計重要的一部份，勞動與汗水交織的設計原來是如此的有趣；三、同學們都對於自己的作品感到滿意且深受感動；四、認識好多其他年級的同學，又可以一邊工作一邊遊戲沒甚麼壓力；五、好像開始敢講點英文了，也了解到了一些北歐的設計理念。個人也深深覺得這是我們執行的最成功的一次國際工作營，雖然參與的學生人數非常多，而且指導教授來自遙遠而且是我們所不熟悉的北歐，事隔多年之後還常常聽到學生提起這次有趣的工作營。

　　因為個人的怠惰，隔了幾年後才將這個工作營的成果付梓，有許多同學都已經畢業，但是回想起工作營時同學收工後一起烤肉的歡樂景象歷歷在幕。最後得感謝各組的指導老師，還有張家瑞、袁義祖與高鼎鈞系友的排版與編輯才能讓這小冊子完成，更感謝河康與卡馬可教授的參與以及對於工作營所投注的心力。

淡江大學建築學系陳珍誠

TAMKANG INTERNATIONAL WORKSHOP

Postscript of City Zen Garden Workshop

To increase the international outlook of our students, the Department of Architecture at Tamkang University has held an international workshop each spring since 2003. We let students interact with different grade levels by mixing the grades together into groups, giving the freshman a chance to be lead by the seniors. In 2003, we invited an important architecture group from the U. K., the Archigram, to host the workshop, "Did you realize you were wearing your closet?" In 2004, we had a famous post-modern architect, Mr. Takefumi Aida, host a workshop called, "I hope to design this kind of Tamsui Township." Then, in 2005, Japan's well-known Digital Architecture architect Makoto Sei Watanabe, hosted the "Scatter/Gather" workshop.

Based on the experience of those three years, in 2006, after a discussion between students and teachers, we decided to go outdoors to do actual design and construction. After a discussion between the international workshop's host and our guest professor from Finland, Professor Macro Casagrande, we decided to invite Mr. Haakon Rasmussen, a member of the famous architecture group called "3RW Architects", to co-host the workshop. He was happy to help us, and came all the way from Oslo, Norway to Tamsui, Taiwan.

The workshop's subject was organized by Professor Macro Casagrande in 2006, and was called, "City Zen Garden." In principle, each team of students had to build a 5.0 meter long by 2.5 meter wide Zen Garden (about the size of a parking space). This was a free entry workshop. We had many enthusiastic students sign up, one hundred and ninety students in total, including twenty-two graduate students, who were the teaching assistants for each team, and fifty-five seniors, forty-three juniors, four sophomores and sixty-six freshmen students. We divided all of the students into eighteen groups. In addition to the full-time and part-time teachers from our department, we also invited several graduates to join the teams as group instructors.

On February 22nd , 2006, the second day of Mr. Haakon Rasmussen's arrival, we surveyed the site of the workshop in a light rain. We prayed for good luck at the earth god temple next to the workshop, and that the next few days would run smoothly. According to Taiwanese custom, when a construction project starts, you need to respect heaven and earth and then everything will go well.

On the morning of February 23rd, Mr. Haakon Rasmussen gave the speech "The Cultivating Man - Participation in Landscape." After lunch, our group of two hundred people diligently marched from the department and headed to the site. Most of the students rode their motorcycles from school to the workshop, which is about a fifteen-minute ride. The workshop was located behind the Zhu-Wei MRT Station, between the Tamsui river and the tracks of the MRT Tamsui line. Professor Huang Rui-Mao and sophomore student Hong Jing-Jiang negotiated with the local farmers and convinced them to offer us the site for free. After discussions, Professor Haakon Rasmussen lead teams 1 through 9 to design City Zen Gardens in the wastelands of the northern section of the site. Professor Macro Casagrande lead the other nine teams, 10 through 18, to work on their projects in the southern section of the site, near the inter-tidal riverbank facing Guan-Yin Mountain.

The workshop covered four full days, from the afternoon of the 23rd to noon of the 27th, and that afternoon we had commenting on the final designs. In the beginning, the students decided not to spend any money to finish their projects, so everybody had to follow this rule. On the first day, each teams looked for the right place to design their Zen Garden and once they started to work on the soil preparation, they gradually realized their different needs. For example, after the students weeded the place, and they began digging down shovel by shovel, they may have found tiny rocks or a larger rock with a diameter of more than 30 centimeters. They may have found demolition waste indiscriminately dumped in the bushes, or they may have needed to struggle with the tide. These are the unexpected situations and actual challenges that can not be experienced by designing on paper in the studio at school. Therefore the students needed to build their site and change their design at the same time. These were brand new designing experiences for the students. We are grateful to Professor Liu Qi-Wen for translating so that the students without a great understanding of English could still understand the two foreign professors' comments and guidance.

A light rain fell throughout the days of the workshop, but the students were always excited and energetic. With bare feet or rain boots, or just a simple raincoat, the students worked hard in the mud, and looked just like the subject of Professor Haakon Rasmussen's speech, "Farming Man." We also want to thank professors Bi Guang-Jian, Wang Jun-Xiong and Su Rui-Bi as the general commanders who made the workshop run smoothly, and without any students being injured.

After four days of hard work, the final results from each team are collected in this booklet, and the students became aware of a few points of great significance from the workshop:

1.The site is full of life, and it's also the inspiration for their creative design.
2.Actually building their original designs is an important part of design. The students found that putting their own sweat and labor into their projects was fun.
3.The students were satisfied and touched by their own projects.
4.They were able to meet many students from other grade-levels and by at one time working and playing, they didn't feel any pressure.
5.The students started to feel more comfortable communicating with the professors in English and they learned more Northern European designing ideas from this.

Personally, I deeply feel that this was our most successful international workshop ever. Although a very large number of students were involved, and the guest professors were from a distant place in Northern Europe we were unfamiliar with, we still hear mention of this interesting workshop from students several years later.

Because of my own laziness, I have this report done a few years after the completion of this workshop. Many of the participating students have already graduated, but I still have a vivid picture of the barbeque with the students after the workshop was complete. Finally, we have to thank each teams teachers for their guidance, and the graduates Chang, Jia-Rey, Yuan, I-Tsu and Kao, Ting-Chun for their help in typesetting and editing this booklet. And we more than appreciate Professor Haakon Rasmussen and Professor Macro Casagrande for their help and for putting so much into the workshop.

by Prof. Chen-Cheng Chen, Department of Architecture, Tamkang University

淡江大學建築系國際設計工作營
城市「禪」園工作營

	老師名單	組員名單
01組	王俊雄	林頎軒 蕭易兒 方琳 陳馨怡 吳宜倫 張淑婷 顏紹竹 鄭如庭 陳蕊希 徐啟泰 林哲宇
02組	林志帝/吳靜方	鄒永廉 廖子翔 林宏聰 莊明蕙 李訓銘 蔡宜初 吳奕瑋 蔡昀昕 吳柏緯 黃玉彬 徐衛邦
03組	楊恩達	張勝茂 楊孟凡 林雨寰 黃凱俊 蔡富全 鄭宇格 蔡霈菁 陳博元 陳彥妏 楊鈺偉 湯天維
04組	蘇睿弼	陳敏傑 林蘊亭 莊馥名 杜偉立 謝嘉羲、蔡宜臻 蔡靜緹 蔡逸鈞 林耀正 范舒雅
05組	李佩璋/林欣蘋/張舜翔	梁騰 高銘樺 李振嘉 吳可柔 孫文宣 邱郁晨 姚信潔 徐儒 李宛倩 黃平瑋 呂紹寬
06組	楊尊智	蔡隱儀 胡國裕 楊海琳 柯鈞耀 帥文浩 劉佳語 葉哲瑋
07組	謝明達	文翊瑋 吳子建 許紋菁 沈家豪 呂紹誠 薛樹揚 張玉屏 蔡怡祚 戴瑋志 李書儀
08組	徐昌志/郭思敏/蔡孟芬	張創霖 徐嘉豪 李能真 林昇漢 俞瑩 張印光 何佩璇 林庭婷 陳郁婷 陳維剛 張世麟
09組	李盈芳	翁偉真 謝宛蓉 吳聿淇 陳逸珊 陳右昇 謝明軒 簡文煌 葉靜儀 謝仲凱 劉筑甄
10組	黃瑞茂	陳英男 何銘瑋 楊雅玲 吳訓漩 吳明玄 鄭宇晴 羅若瑋 柯濬彥 陳騰輝 邱彥勳 鄭明輝
11組	曹羅羿	王芊文 王祈雅 吳怡宏 黃國華 林與欣 周佑亮 鍾業敏 陳德凡 蔡宗佑
12組	邱鄭哲	郭志雄 陳良 葉佳奇 張傑宜 曾建瑋 陳鑫翰 盛恩正 陳慶懋 王博謙 林怡芳 張惇涵
13組	畢光建	李京翰 陳明怡 陳思芸 謝安邦 林苡安 黃思銘 陳沛欣 陳慕煒 陳少喬 蔡宜凌 楊宏偉
14組	加藤義夫	張紹賢 李亞芳 蔡祐緯 林育蔚 張美鈴 林詩翔 陳繪安 吳宛倩 蔡宇任 董震剛
15組	宋偉祥/陳曉彤	李馬文 周芸鍵 林均郁 賴靜芬 林永仁 潘志榮 袁以真 晏可奇 蕭凱倫 張維茹 鄧振甫 張則舜
16組	張恭領	李孟浩 蔡孟寰 謝佩芳 張文睿 吳介元 保琳 李怡瑩 陳志昇 歐湛瑜 陶珩
17組	江之豪	陳力鵬 童尚仁 吳婉茹 林于雯 王冠閔 林宜進 吳乾弘 劉亦欣 詹婉琳
18組	鄧海/游國昌	張鈞鳴 黃鈺華 秦君文 余采真 李奕辰 李岱俐 黃暘諭 翁雅君 陳釕廷 謝宗諺

淡江建築 TA002　　　　　ISBN　978-986-5982-51-5

城市禪園

作　　　者	Haakon Rasmussen 河康	
	Marco Casagrande 卡馬可	
	Chen-Cheng Chen 陳珍誠	
美術編輯	張家瑞、袁義祖、高鼎鈞	
發 行 人	張家宜	
社　　　長	邱炯友	
總 編 輯	吳秋霞	
出　　　版	淡江大學出版中心	
	地址：25137 新北市淡水區英專路151號	
	電話：02-86318661/傳真：02-86318660	
總 經 銷	紅螞蟻圖書有限公司	
	地址：台北市114內湖區舊宗路2段121巷19號	
	電話：02-27953656/傳真：02-27954100	
出版日期	2014年8月 一版一刷	

定　　　價　240元

國家圖書館出版品預行編目資料

城市禪園 / 河康(Haakon Rasmussen), 卡馬可(Marco
Casagrande), 陳珍誠作. -- 一版. -- 新北市：淡大出版中心,
2014.06
　　面；　　公分. -- (淡江建築；2)
ISBN 978-986-5982-51-5(平裝)
1.建築美術設計 2.作品集
920.25　　　　　　　　　　103009909

本書如有缺頁、破損、倒裝、請寄回更換

退書地址：25137 新北市淡水區英專路151號M109室